THE AESTHETIC THEORIES OF FRENCH ARTISTS
1855 TO THE PRESENT

THE AESTHETIC THEORIES

OF

FRENCH ARTISTS

1855 TO THE PRESENT

BY

CHARLES EDWARD GAUSS

BALTIMORE

THE JOHNS HOPKINS PRESS

1949

SECOND PRINTING, 1950
THIRD PRINTING, 1957
FOURTH PRINTING, 1963

PRINTED IN THE UNITED STATES OF AMERICA
BY J. H. FURST COMPANY, BALTIMORE, MARYLAND

PREFACE

This study is a modest attempt to trace some of the connections between art and other branches of human endeavor and culture in the history of ideas. Its thesis is that one should examine the history of ideas as it is manifested in art.

I have included in my discussion only those artists and those writings which I deemed sufficient to trace the course I wished to outline. If the study is of any value others better equipped than I may fill in the outlines.

In rendering the French quotations in English I have made my own translations, though often better ones are available, in order that any responsibility for misunderstanding may be laid only to me.

I wish particularly to thank Dr. George Boas and Dr. Lionello Venturi for their kind aid and interest in the present undertaking. I am also grateful to them and to Dr. Pedro Salinas and Miss Etta Cone for having made available to me materials from their libraries which it would have been otherwise difficult or impossible to obtain.

Acknowledgment is made to *The Journal of Aesthetics* for granting me permission to incorporate here materials published in that journal on surrealism.

Acknowledgment is also made to the following copyright holders from whose works passages have been quoted in this book: The University of Chicago Press for selection from D. C. Rich, *Seurat and the Evolution of " La Grande Jatte "*; The Dial Press, Inc. for selections from C. J. Ducasse, *The Philosophy of Art*; Dodd, Mead and Co., Inc. for selection from C. G. Jung, *Psychology of the Unconscious*; Faber and Faber Ltd. for the selections from A. Breton, *What is Surrealism?*; Mr. Julien Levy for the passage from S. Dali, *Conquest of the Irrational*, and the

viii *PREFACE*

passage from J. Levy, *Surrealism*; The Open Court Publishing Co. for the sentences from B. Russell, *Our Knowledge of the External World*; and to Mr. Walter Pach for the selections from his article " Pierre-Auguste Renoir " in *Scribner's Magazine* for May 1929.

Translations have been made from materials held by the following copyright owners: Art Catholique (L. Rouart and J. Watelin), publishers of C. Cennini, *Le livre de l'art*, translated by Victor Mottez, and M. Denis, *De Gauguin et de Van Gogh au classicisme, théories 1890-1900*; Beaux Arts, *Dictionnaire abrégé du surréalisme*, and R. Rey, *La renaissance du sentiment classique*; Jean Budry et Cie., T. Tzara, *Sept manifestes dada*; G. Cres et Cie., Jean de Rotonchamp, *Paul Gauguin 1848-1903*; Durand-Ruel, L. Venturi, *Les archives de l'impressionnisme*; Figuière, A. Gleizes and J. Metzinger, *Du cubisme*; Librairie Floury, P. Signac, *D'Eugène Delacroix au néo-impressionnisme*; Librairie Gallimard, A. Breton, *Le Surréalisme et la peinture*; Éditions Bernard Grasset, P. Cézanne, *Correspondance*, edited by J. Rewald; *Journal Havre-Éclair*, issue of September 25, 1904 containing statement of Pissarro; M. Henri Matisse, whose article, " Notes d'un peintre " appeared in the *Grande Revue* for December 25, 1908; H. Laurens (Librairie Renouard), E. Moreau-Nélaton, *Manet raconté par lui-même* and H. Focillon, *La peinture du XIXᵉ et du XXᵉ siècle*; Éditions du Sagittaire, A. Breton, *Manifeste du surréalisme* and *Second manifeste du surréalisme*. I thank all of these who gave me their kind permission to print my translations.

And to all those who aided me with their comments or in the preparation of the manuscript I extend my grateful appreciation.

CHARLES EDWARD GAUSS

The George Washington University,
March 7, 1949

TABLE OF CONTENTS

THE AESTHETIC THEORIES OF FRENCH ARTISTS
1855 TO THE PRESENT

CHAPTER ONE

INTRODUCTION

ARTISTS have frequently written about their art. Numerous instances come to mind. The *Treatise* of Alberti on painting and the *Notebooks* of Leonardo da Vinci are famous among the writings of the Italian painters. Hogarth's *Analysis of Beauty* and Reynolds' *Discourses on Art* came at the time of awakening interest in aesthetics in England. There are posthumous publications of the *Journals* of Delacroix, Redon, Whistler, of the correspondence of Van Gogh, Gauguin, Cézanne. In the twentieth century books and essays written by artists have multiplied extensively. Indeed, it has become quite the accepted thing for artists today to publish some statement of their aims or an explanation of their aesthetic, especially when their work is of a new or strange character.

The literary preface is common for the professional writer, and surely we should find nothing amiss in the extension of the use of the preface to the plastic arts. If anything, it is logically more necessary to have a declaration of artistic intentions for works in this field than for literary efforts. Literature uses the universally comprehensible language of speech, but the medium of painting is not so readily understandable to the average person. The fact that an artist states his aesthetic credo indicates that he does not trust the unaided sensibilities of the spectator before his work. The arts have become sophisticated like the sciences. The naïve attitude of the average man is no longer sufficient to comprehend them.

The naïve attitude is that which contents itself with whatever minimum mental effort is necessary to grasp the

3

practical life. It accepts the space of Aristotle, the axioms of Euclid, and snapshot art.[1] These seem to have the advantage of being substantiated fundamentally in daily experience; and their acceptance becomes a habit of mind, tenaciously held and rarely questioned. Toward modern science the average man is occasionally willing to admit the insufficiency of his naïve attitude. Awed by the concrete technological advances of science during the last two centuries, he is willing to assume a docile and uncritical attitude towards the new physics. Quantum theory and relativity have merited his respect. Before them his attitude becomes submissive. On the other hand, before modern art, which his naïve attitude renders him incapable of understanding, the average man is anything but submissive. The art of the new movements of the twentieth century call forth his immediate reactions. Art which cannot be understood is not to be left alone until one does grasp it. It must be judged immediately, judicially.

Though we must recognize the existence of such an attitude, we must not let this naïveté be the court of judgment for our art. It must be educated and refined, at least to where it expresses that same humility that it shows towards new scientific theories.

To know the questions of modern science we go to the chemist, the physicist. To learn the questions of modern art we must go to those who deal with them. We must see the problems presented by the painter's materials, techniques, and objectives, and we should understand the various solutions of these problems. The artists themselves can best present these problems to us.

The study of artists' manifestoes and pronouncements has not, of course, been neglected. In art histories and monographs on artists they have been examined for the purpose of setting in clearer light the producing personali-

ties and of better understanding their artistic productions. Critics of art have referred to them for similar reasons, or to support their own artistic judgments by comparison or contrast. But it is possible to use these writings as materials upon which to base a further study. We may probe back to the more fundamental philosophical ideas, the metaphysics as it were, upon which the individual taste of an artist or the doctrine of a movement in art is founded. There are often certain leading ideas, presupposed notions, or tenets of faith which are like guiding lines for much of the human activity of a time, being observable in thought, science, and art. The theories of the artists thus become materials for the manifestations of ideas in history.

The legitimacy of basing a philosophical inquiry upon the words of artists may be challenged. These theories were not written as philosophy and whatever philosophical content they have will be meager and poorly stated. Philosophical questions are for the philosophers, not the painters, to solve. Curt Ducasse ably expresses this criticism:

When questions of this sort present themselves people generally assume as a matter of course that, of all persons, the artist must be the one best able to answer them. But the artist's business is to practice art, not to talk about it. Indeed, an artist with a theory should be regarded *a priori* with suspicion, for such an one is likely to paint or sing with his intellectual conscience instead of his feelings, and to give us, therefore, not works of art but moral documents.

It would not be much more foolish to expect a lecture concerning the physiology of digestion from a man who can eat things indigestible to others, than it is to expect answers to questions of the sort mentioned from a painter on the strength of his ability to paint pictures. But people, failing to see this, insist on making the artist talk. They regard him as an expert, and naturally he admits being one,—he as well as his questioners innocently but unfortunately overlooking the fact that it is at something very different from dealing with theoretical questions concerning art that he is expert.[2]

To this criticism two answers may be given. First, it assumes that the proper business of the artist is the making of a work of art and that all theoretical questions about art belong to the philosopher. Such an idea that there are some men who are doers and others who are thinkers is the result of a false abstraction. Of course, the artist while practicing his art is a doer, but his work has some mental direction, and if he at all thinks about what he does there is no reason why he should not talk about it. Artists do theorize and we have a right to take the results of this theorizing as materials for study.

Second, if the object in going to the artists' theories were to find in them acceptable answers to purely philosophical questions, the criticism of Professor Ducasse could be legitimately urged against such a procedure. The philosophy of an artist who theorizes may be as bad as that of the scientist who grows metaphysical. Speculative philosophy is frequently upon shaky enough ground when indulged in by philosophers, to say nothing of when others, not so aware of weaknesses in their assumptions, add their elaborations. However, we do not go to the theories of the artists to find answers to aesthetic problems but turn to them as materials for philosophic study. The purpose is to analyze an aesthetic as viewed in the light of its presuppositions.

The present work is a modest attempt to do this. The material used is a selected group of representative writings by French painters from 1855 until the beginning of the Second World War. The study starts with the realism of Courbet because here one finds the best link between the art of the past and the new painting that was to come to fruition in the twentieth century. By starting with it and considering later theories in the light of it, the study that follows is given the general thread of the history of an idea.

The story of French painting in the latter half of the nineteenth century may appear to be a series of revolutions and counter revolutions. Yet it can be presented as an intelligible pattern. From the time of the rebellion against idealism French painting has been predominantly realistic. Courbet, the impressionists, the neo-impressionists, Cézanne, were concerned with the appearance of the external world. Renoir, the symbolists, the fauves, the surrealists, though they may have been primarily interested in expression or the revelation of the inner self, never idealized their subject and retained a kind of primitive naturalism. The cubists, though they seemed to discard appearance for reality, were concerned with the nature of the object as three dimensional and intellectually known. Consequently every style of painting from the time of Courbet may be looked upon as a variation of realism or a reaction against its original form.

The dialectic of the historical development of philosophy in France from the time of positivism is too complicated to sum up in relation to the artistic development which was much simpler. It is sufficient to notice that the early positivism which limited knowledge to the immediately observable was soon shown insufficient and subjected to criticism and emendation. The place of hypothesis, the contributions of the human observer were noted and taken into account. The reaction to the severe scientism of this tradition began with Ravaisson and Bergson as these men offered new interpretations of consciousness and intuition. French philosophy divided into two schools, the scientific philosophers and the intuitionists. 'Roughly this division corresponds to the " scientific " painters, neo-impressionists, Cézanne, cubists, as opposed to the expressionist or intuitionist painters, Renoir, the symbolists, the fauves, the surrealists. Without an exhaustive study of every

minor development and change in French painting it is impossible to connect the artistic and philosophical developments completely. I have preferred to keep the thread of connection in the artistic field and then point out such parallels with philosophy as may occur. This is sufficient to support the contention that the aesthetic theories of the artists do have philosophic roots or are analogous to some ideas in philosophy.

Sometimes the relations pointed out are definitely ones in which the artistic ideas depend on certain philosophical presuppositions. This is the case in relation to realism. At other times the artist in his aesthetic has consciously borrowed and used ideas from another field. Such has happened in surrealism. At still other times there may be noted notions which are striking for their similarity between art and philosophy. An example of this is the resemblance between the cubist painter's object and the constructed object of the new realist philosophy. Since the concern here is to demonstrate philosophic backgrounds all three kinds of parallels are pointed out.

This history of ideas is a history of painterly problems not of philosophical theories.

NOTES

[1] The word snapshot is used instead of photographic to convey more precisely the impression of uncritical, amateurish immediacy.

[2] Reprinted from *The Philosophy of Act* by C. J. Ducasse, p. 2, by permission of Dial Press, Inc., copyright 1929 by Dial Press, Inc. Also *vide* L. A. Reid, *A Study of Aesthetics*, p. 15, for another expression of this same notion.

THE REALISM OF COURBET

THE ART world of the Second Empire was like an exclusive club. It had its own standards and rules of admission that forced the individual artist to its pattern. There was no room for the independent or the revolutionary. And so it was that in 1855 the jury of the Exposition rejected the work of Gustave Courbet. Incensed at this rebuff, the artist rented a pavilion near the exposition grounds and proceeded to hold his own one-man exhibition of forty paintings, labeling his art realism. As the leader during the fifties of the rising radical painters, Courbet gained by this act historical if not popular notoriety and set painting alongside of the rising new order in literature. For the next fifteen years realism was destined to be the center of opposition to the official and academic art of the Second Empire.

Courbet's convictions on painting are contained in two manifestoes. The first was published in 1855 in the catalogue of his independent exhibition. Though over his signature it was most probably written for him by Champfleury, the pioneer exponent of realism in literature.[1] This manifesto is very brief, merely stating that realism is a label applied as romanticism had been in 1830, that the artist has studied the painters of history not to copy them but " to know in order to be able to do," that he is opposed to the theory of art for art's sake, and that he wishes only to translate the manners and ideas of his epoch, in other words " to make a living art." [2]

In the number for December 25, 1861 of the *Courrier du Dimanche* Courbet published a longer statement of his

theories, which had by now become crystallized in his own mind, to explain his refusal to direct a school for artists which the young realists had requested. His words sum up the position of the realist:

I cannot teach my art, nor the art of any school, since I deny that art can be taught, or as I maintain, in other words, that art is strictly individual and is for each artist precisely the talent resulting from his own inspiration and from his own studies of tradition. I add that art or talent according to me should be for each artist only the means of applying his own faculties to the ideas and things of the epoch in which he lives.

Especially the art of painting should consist solely of the representation of objects visible and tangible to the artist. Any epoch should be reproduced only by its own artists, I mean to say, by the artists who have lived in it. I hold the artists of one century radically incompetent to reproduce the things of a preceding or future century, or otherwise to paint the past or the future.

It is in this sense that I deny historical art applied to the past. Historical art is in its essence contemporary. . . .

I also hold that painting is essentially a *concrete* art and does not consist of anything but the representation of *real* and *existing* things. It is a completely physical language using for words all visible objects. An abstract object, one which is invisible, non-existent, is not of the domain of painting.

Imagination in art consists in knowing how to find the most complete expression of an existent thing, but never to suppose or create that thing.

Beauty is in nature and is found in reality under the most diverse forms. After it is found there it belongs to art, or above all to the artist who knows how to see it. Rather, beauty is real and visible, it has in itself its own artistic expression. But the artist has not the right to amplify that expression. He cannot touch it without risk of changing its nature and consequently of weakening it. The beauty given by nature is superior to all the conventions of the artist.

Beauty, like truth, is a thing relative to the time in which it is seen and to the individual fit to conceive it. The expression of beauty is in direct ratio to the power of perception acquired by the artist.

There is the groundwork of my ideas on art. With such ideas, to conceive the project of opening a school to teach conventional princi-

ples would be to resume again the incomplete and banal ideas which have up to now guided modern art everywhere.

There cannot be schools; there are only painters. Schools are only of use to investigate the analytic procedures of art. No school can bring one by resolution to the artistic synthesis. Without falling into abstraction, painting cannot let a partial aspect of art dominate, be it drawing, color, composition, or any other one of the many ways of which only the ensemble constitutes art.[3]

How terrible! the official artist must have thought upon reading this. One cannot paint nymphs, angels, or muses. This madman denies the artist the right to paint scenes from classical antiquity, from the Bible, or from national history. The artist cannot beautify his subject, for beauty is supposed to be the bald, literal statement of fact. This man is denying all the glorious traditions and teachings of art. Great art has always been a thing of ideals, the result of a noble imagination; this man, like a scientist, makes it a work of fact. As well call a daguerrotype art!

Between this official artist and Courbet there was the bridgeless chasm that separates the " realist " and the " idealist." Idealism makes the world a construction of our own minds and its aim is mathematical explanation and abstraction. Realism assumes the world as given and its aim is description and observation.

The meaning of realism does not change when we pass from the realm of thought to art. The realist artist seeks to omit the subjective and to reproduce the world as seen. He is a descriptive artist who states without comment.

Realism in thought and art, therefore, are closely allied; and it is possible to find in the world of the Second Empire intellectual trends that parallel the rise of realist art.

The new thought of the mid-nineteenth century is positivism, which assumes that the world is the sum of those objects that the scientific observer finds in his experience.[4] Our knowledge is confined to the data of experience. The

purpose of science is to collect the instances of the occur-
rence of an event and to generalize them in a formula. No
metaphysical power or substance which might be the cause
of that event is discoverable nor needs to be invoked. We
disregard what we are unable to verify empirically; "see-
ing is believing" is literally interpreted. Scientific method
brings us to the discovery of general principles which are
thus only descriptions. The mind is a passive end-organ
which receives the data and organizes them, adding noth-
ing of its own construction in the formulation of the
principles.

Realism accepts completely this positivistic outlook.
Painting is the representation purely descriptively of ob-
jects which are visible and tangible, or real and existing.
The duty of the artist, like that of the scientist, is to ob-
serve, analyze, and describe accurately by a detailed re-
production the object of nature as it is seen. Unseen
objects are metaphysical abstractions and have no place
in painting. Beauty is a perceptible quality in seen objects
and the artist simply reproduces this beauty. The im-
agination is a strictly perceiving and reproducing faculty;
it cannot create; it contributes nothing to the beauty of
the work of art. The artist is only the vehicle through
which the language of painting operates, and the more he
effaces himself to become the "slave of his model"[5] the
better is beauty translated from the natural object to the
work of art.

If the aim of art is exact reproduction of natural objects
then the purpose of art can no longer be the one that had
been usually assumed, the embellishment of the world by
ideal beauty. The new justification of art is the declara-
tion that it has a social purpose. When Courbet says that
the artist must represent his own epoch not the past or
the future, and that he wants to make a living form of art

by expressing the ideas and customs of his age, he is again voicing the sentiment of positivism and nineteenth century criticism of art.

In 1828 Émile Deschamps had said: "Above all else one must be of his time." [6] In the field of art criticism after 1830 a group of writers whom we may roughly call the democratic school emphasized the social end of art through their *Salons* and journals articles. They included Étienne Arago, Alexander Decamps, Henri Robert, Louis Dessieux, Charles Blanc, Theophile Thoré, and J. A. Castagnary.[7] These men had variously held some form of belief that art is a kind of social documentation or a vehicle for social betterment. Either directly or indirectly all these had been influenced by the increased interest in social problems manifested by the Saint-Simonists or the positivists of later generations.

In the years following 1815 Saint-Simon and the group about him set forth what they believed were the essential aesthetic needs of man and the services the artist can render to society. They looked upon society as moving toward an ideal order. Since society is an organic unit which includes the arts within it, art will have a part in bringing about this ideal order as well as being a unit in the present order. In a society the learned, the artist, and the artisan perform the work of positive utility. When the physical and moral needs of man are satisfied, he will be happy. In the new order to come industry will meet our physical needs and be the basis of society. Art is the moral expression of a society and its guide. It is the agent of social reform through its influence in inspiring love of liberty, or by its power to produce a social revolution. But a noble art is impossible until after the social reform. To see that a social order founded on industry will produce the highest art, we need only look at the flourishing

condition of the arts in the commercial cities and civilizations of the past. Such was the optimism of the Saint-Simonists.

Comte found a methodological basis for this optimism. According to him scientific explanation has developed through three stages. In the first, the theological stage, phenomena are explained as caused by some divinity or spirit. This is the stage of primitive and ancient peoples. In the second, the metaphysical stage, explanation is by means of abstractions, such as substances, causes, forces. This is the stage of the Middle Ages. In the third or positive regime, explanation is description of appearances. Comte had arranged the sciences according to the historical order in which they achieved the positive status. The list he gave was mathematics, astronomy, physics, chemistry, biology, and sociology. To him this was an exhaustive classification. Each science is more inclusive than the ones preceding it and presupposes them. Sociology, the crowning science, is the study of man in his social setting and with all his activities. The aesthetic activities of man gain purpose only when seen in the light of the perfect positive regime of the future.

According to Comte art is an ideal representation of what is. The domain of art like that of science embraces all reality. Science estimates it; art embellishes it and is a social necessity. The imagination is subordinated to reproduction and description. Politics, art, and philosophy begin in the study of inorganic nature then pass to the study of man as intellectual and finally as moral. Since the aesthetic faculty is intermediary between intellectual and moral faculties, art emanates from philosophy and prepares politics, and rises with least effort to the contemplation of moral values.

The third step in the development of positivistic aes-

thetics is found in P. J. Proudhon's book *Du principe de l'art*, published posthumously in 1865. It is often credited with being the complete expression of realist aesthetics. It is the positivistic apologia for the subordination of art to political and social ends. Proudhon was a good friend of Courbet and it was he who persuaded Courbet to paint with some social consciousness.

The aesthetic faculty and its place are Proudhon's first theoretical considerations. He is against the separation of art from morals and philosophy, and the theory of art for art's sake, because he believes both attitudes are founded on a false theory, namely, that the aesthetic faculty is equal to the two great faculties of the soul, conscience (or justice) and science (or truth), to which he considers all others should necessarily be subordinated. Conscience and science are the poles of the human soul. They are the two equal and opposing powers from whose operation arises the artistic ideal of life. The aesthetic faculty cannot be equal to these two for it is only a sensible faculty. It is by definition " the faculty in man by which we perceive or discover beauty and ugliness, the agreeable and the distasteful, the sublime and the trivial in ourselves and in things and make from this perception new means of enjoyment for ourselves." [8] Art, which continues the creative work of nature, is an " idealist representation of nature and ourselves in view of the physical and moral perfection of our species." [9] So closely bound up are art, morals, and society that the taste of a society is the measure of its moral and intellectual culture. The artist, according to Proudhon, should be of his time and place but as a critic of them, for his aim is to be a prophet of humanity. Since, as a positivist, he believes the perfect society is in the future, the present society must be condemned. Therefore, the purpose of art as the expression of a society, is to

comment on that society to the end of destroying it in order to build a better one.[10]

The consideration of positivistic aesthetics as the first to preach consciously the gospel of the social purposes of art is not accidental to a discussion of realism. Though Courbet does not go to the length of talking about the social obligation of art toward a new order in the future, he does justify art as a kind of social documentation. And his realism grew out of his political socialism. It was part of his rebellion against the Second Empire and its artificialities.

According to Courbet beauty is a real and visible quality in things waiting to be discovered by those whose perception is sensuously attuned to it. It is found in diverse forms in nature, and artistic expression renders it through copying the appearance of the model.

The idea of the diversity of beauty was part of the nineteenth-century romantic rebellion against idealist art. Delacroix was declaring that " the sight of the beautiful works of all times proves that beauty is not always met under similar conditions " and that " one must see beauty where the artist has wished to put it." [11] Baudelaire was exploring new dimensions of beauty in his poetry. The grotesque and the ugly, the ordinary and the everyday were receiving attention as species of the beautiful. The subject matter of painting was being extended to all the " ignoble " subjects that the idealist had spurned. Courbet was being the child of his time in this respect, too.

Though beauty has a variety of manifestations according to Courbet, and though the artist renders it by reproduction of appearances, the beauty is not the appearance itself. It is *in* the appearance of an object, a quality which carries its own expression. As such it is a kind of abstract general quality which to the positivist is a vestige of the

metaphysical stage of culture. Courbet's theory of beauty is not consistent with his positivism. A reinterpretation of beauty in concretely verifiable terms is needed. Realist artists following Courbet will think of a specific quality of an object such as its lighted surface or talk of the definite elements of painterly composition such as the color harmony. The word beauty will not be so important in their vocabularies.

Courbet's notion of beauty demands that the artist imitate the appearance of his model, for he cannot improve upon or embellish nature. As painters begin to move away from such an idea of beauty and to look at art in terms of the rendition of a character of the object they begin to feel the inadequacy of the theory of art as exact imitation. They begin to modify the theory of imitation or rebel against it completely, moving over to some notion of expressionism.

Something of this shift can be found in the philosophy of art of Taine. He is usually thought of as the aesthetician *par excellence* of positivism and realism, but actually in him we begin to find the transition of realism into its historical consequents. Taine was interested mainly in establishing an aesthetic theory by which to understand works of art. Though he defines art as imitation it is not " pure " imitation. A work of art exists for a definite purpose; " The end of a work of art is to manifest some essential, salient character, consequently some important idea, more clearly and completely than is obtainable from real objects." [12] The artist chooses one character of natural objects and renders this predominant by systematically modifying all others to conform to it. Taine describes the impressionist procedure.

Eugène Véron carries the rebellion from imitation even farther. He declares that beauty is an insufficient principle

to explain art for beauty leads to the idea of imitation. But imitation in art is not what we admire, but the genius of the artist. The art of the future will be expressive art wherein the artist will reflect the "measure of his own sensibility, of his own imagination, and of his own intellect." [13] Véron points to the artist as expressionist.

Following the pattern of these two aestheticians subsequent artists will modify or deny the principle of imitation, answering as best they may the problems that surround the changes they make in the realist postulate.

NOTES

[1] Cf. R. Dumesnil, *Le réalisme*, p. 12; and H. Focillon, *La peinture au XIXᵉ et XXᵉ siècles du réalisme à nos jours*, p. 7.

[2] Courbet, "Manifeste 1855," in C. Leger, *Courbet*, p. 61.

[3] Courbet, "Manifeste 1861," in C. Leger, *op. cit.*, pp. 86-88.

[4] Cf. G. Mead, *Movements of thought in the Nineteenth Century*, p. 459.

[5] Phrase taken from T. Silvestre, *Artistes françaises*, vol. II, p. 145.

[6] Émile Deschamps (1791-1871), French romantic poet, whose Préface to *Études françaises et étrangères*, 1828, is one of the manifestoes of romanticism. Quotation from Préface, p. xvi (4th edition, 1829).

[7] Cf. H. A. Needham, *Le développement de l'esthétique sociologique*, pp. 81-83; L. Rosenthal, *Du romantisme au réalisme*, pp. 370-374; G. Larroumet, "L'art réaliste et la critique," in *Revue de Deux Mondes*, Dec. 15, 1892 and March 1, 1893.

[8] P. J. Proudhon, *Du principe de l'art*, p. 17.

[9] *Ibid.*, p. 43.

[10] What better defense than Proudhon might Baron Haussmann have invoked, for if he did destroy much property which obstructed the paths of his projected boulevards, if he did seem to waste money on extending these magnificent avenues out into the fields beyond the city, was he not changing the present only to make a better future? Cf. S. Giedion, *Space, Time, and Architecture*, pp. 465-480.

[11] E. Delacroix, "Questions sur le beau," *Revue des Deux Mondes*, July 15, 1854, pp. 307 and 312.

[12] H. Taine, *Philosophy of Art*, tr. J. Durand, London, 1865, p. 64.

[13] E. Véron, *L'esthétique*, p. 150.

CHAPTER THREE

FROM REALISM TO NEO-IMPRESSIONISM

and Millet

FOLLOWING COURBET the succession of painters
from Manet to the impressionists and neo-impression-
ists modified progressively the realist doctrine, moving
painting away from the idea of imitation and introducing
increasing emphasis on the role of perception.

After the notoriety of the Salon des Refusés in 1863
Manet became the leader of the realists as Courbet had
been the decade before. During these last years of the
Second Empire Manet was an influential factor in further-
ing among the younger men who met frequently in the
Café Guerbois the new ideas that were to issue in impres-
sionism. Whatever aesthetic he had is better found in his
paintings than in written words. However, there are two
brief purported quotations which may be given for what
they are worth:

Conciseness in art is a necessity and an elegance. The concise
person makes one think; the verbose person bores. Always modify in
the direction of brevity. . . . In a figure seek the high light and the
deep shadow; the rest will work out naturally; it is often a very small
matter. Furthermore, cultivate your memory, for nature will never
give you anything more than references. This is like a guard-rail that
keeps you from falling into banality. . . . It is necessary always to
remain master and to do that which amuses.[1]

Color is a matter of taste and sensibility. For example, it is
necessary to have something to say; without that you are nowhere
in your art.[2]

As aesthetic these statements are only fragmentary.
But they do hint that Manet's realistic concern was
moving from the subject matter to the form. And they
say enough for one to point out that Manet supposes the

19

artistic process to be a choosing of certain elements from the natural world because they are congenially adapted to artistic rendition. It is not the meticulous over-detailing of what appeared to some as the trivialities of Courbet. This is the first move, consciously so taken by a realist artist toward the doctrine that since the work of art cannot imitate its model it had best be a heightened presentation of chosen characteristics. The admonition to cultivate memory, since nature gives us only raw data, is an admission as well to the further truth that the artist must transfuse these data within his own mentality before they can become artistic material. The positivistic level of experience alone is insufficient for the artist.

Impressionism has been called an "expression of a moment of French sensibility, a rejuvenation of painting not so much by procedures and ideas as by instinct." [3] It was scarcely a clear-cut style, being more a coincidence of taste of a group of painters in the seventies and early eighties who accepted the term impressionism as expressive of their community of interest. They were engaged in an instinctive search for a style, and they found an aesthetic only toward the end of their period of collaborative work. It is for this reason that we find no theoretical defence of any principles of impressionism by the practicing artists. Whatever aesthetic they had remained to be formulated by critics, Duranty, Duret, Geoffroy, Laforgue, and others. It is necessary to consider impressionism here as a link in the general course of the rise of new aesthetic ideas.

The evident intent of the impressionist was to catch the subject that he painted in one of the fleeting moments of its existence. He opened his eyes and looked at the world before him. He found that whatever objects he saw he perceived in virtue of the light they receive and as appear-

ances conditioned solely by this light. Objects are colored shapes, but one perceives the shapes only because they are colored. Hence, if art has any relation to the things of this world (and what realist of the nineteenth century would doubt that it had?), then the play of sunlight on objects through an envelope of atmosphere is the subject matter for art.

Again, as with realism, positivistic description is the ideal. The painter records the perceptual surface of the world, its lighted, visual surface. To go beneath it would be to inquire into metaphysical constituents or interior physical composition.

That impressionism should have chosen light and color as the proper object of the painter's vision seems appropriate if one thinks of the vast amount of work in the fields of physical and psychological optics at this time. The complete papers of Augustin Fresnel on diffraction and polarized light phenomena, unknown or unpublished at the time of his death in 1827, had been published in 1866. So it is reasonable to suppose that by ten years later his work had sufficiently filtered down into popular consciousness to impress it with the notion that monochromatic light is a succession of simple vibrations and that color is a matter of frequency. Or one might recall to mind the importance of Helmholtz and his researches in sensation which formed an immediate groundwork for a physiological theory of perception. Experimental methods when applied to psychology and the science of optics change the character of perceptual psychology from a philosophical science to an experimental discipline. Questions of the relation between the external world and our sensations are approached through the physical study of the propagation and radiation of light. And since these were the kind of questions painting had become concerned with by the time of im-

pressionism, in keeping with the practices of its day, it turned to physical and chemical theories of light and color to solve them.

Also, beginning in the forties seascapes had become a popular subject in French painting. The effect of water reflections opened up to artists a new field, and one which drew their attention to the intensity of light and play of color.

The impressionists first thought that in discovering light they had found all that was necessary to create an art of painting. Record the visual impression exactly as you see it was their dictum. But they soon came to see that this was not factual recording. The artist must intensify and transfigure his object to agree with his impression. Light is morning light, or that of noon or dusk; it is the light from a summer sun or of a winter day; it is the light of rain or cloud or blue sky. If painters are to deal with light alone they must give us those instants. The cathedral façade, the haystack, the seascape could be painted again and again from moment to moment. The subject matter, the object recorded on the canvas, retreats until it becomes no longer subject matter, but merely a perceptual motif over which numerous variations are played. The object is decomposed through the agency of sunlight. On the canvas it is recomposed again through the general harmony of colors. The painters make their analysis for the sake of a new artistic synthesis. This is not the old imitation theory of art. That the impressionists came to realize as they continued their course.

The method of the impressionists is analogous to that of the physicists of the seventeenth century. The latter in defining the world of physics chose those qualities from their experience of the world which were sufficient and necessary for that physics: shape, motion, solidity, exten-

sion, number. The impressionist in making his work of art chose the quality of light which defined for him the existence of the world. Painting is no longer pure imitation of appearances, is not selected kinds of subject matter, but is a way, like physics or mathematics, by which, from selecting certain elements out of the world of experience, we build a world that is our own. It is our own in that we manipulate those elements schematically.

But the primary quality of the impressionists, which they believed was an actual quality inherent solely in the world about them, suffered the same fate as did the primary qualities of Locke when Berkeley pointed out that they depended upon a perceiving mind as well as did the secondary qualities. Impressionism came to see that the quality of light and shade it depicted was far beyond the simple recording of the light effects of nature. The sensibilities of the painters had outstripped recording. Light had been intensified past the place where it had been drawn from nature. It became a formal element usurping the place of structure and was labored beyond its potentialities as the vehicle for form. The ideas of impressionism led to their own disintegration and painters began to search for a new aesthetic. One of the first to rise was neo-impressionism.

By the time of the eighth exhibition of the impressionists in 1886 impressionism was giving way to the neo-impressionism of Seurat and Sisley. Their work showed that the influence of scientific studies on color and light was more thoroughgoing, but it was also marked by the intrusion of an unashamed rationalism.[4] Among the older impressionists Pissarro embraced the new ideas for several years. Each of the three men mentioned gave in brief or extended written form his aesthetic.

Pissarro's theory is found in a letter to Durand-Ruel,

dated November 6, 1886, in answer to one from the latter
asking for complete notes on the painter's life and theory
of art, which were desired for an exhibition of French
painting to be held in New York. Pissarro's reply is
scarcely an adequate theory but it authenticates the ex-
position of the doctrine given by Félix Fénéon and recog-
nizes Seurat as the moving force in the crystallization of
the theory. He says:

My dear M. Durand-Ruel:

I send you here enclosed the notice which you have asked me to
make about my new artistic doctrines.

Would you please complete it by consulting the pamphlet of M.
Félix Fénéon which recently appeared under the title of 'Les im-
pressionnistes en 1886,' for sale at Soiret's in Montmartre and at the
principal booksellers.

If your son brings out a publication on this subject I should want
him to understand thoroughly that it is M. Seurat, a most able artist,
who was the first to have the idea and to apply the scientific theory
after having studied it thoroughly. I have only followed, as have my
other confrères, Signac, Dubois-Pillet, the example given by Seurat.
I hope your son will be willing to render me this service for which I
shall be truly thankful.

Theory

Seek the modern synthesis through scientific means, which will be
based on the theory of colors discovered by M. Chevreul,[5] and accord-
ing to the experiments of Maxwell and the measurements of N. O.
Rood.[6]

Substitute the optic mixture for the pigmentary mixture, in other
words, the breaking up of a color tone into its component elements,
for the optic mixture creates much more intense luminosities than the
pigmentary mixture.

As for execution, we regard it as of no importance, at least as of
very little importance. Art has nothing to do with it, according to us.
The sole originality consists in the character of the drawing and in the
particular vision of each artist.[7]

The important thing for a neo-impressionist is that a
work of art is a synthesis of the color values composing the

canvas. Though Pissarro had turned back from the technique of divisionism characteristic of neo-impressionism by 1890, another statement of his in 1904 shows how completely he was still imbued with the search for harmony:

> I see only spots. When I commence a picture the first thing that I try to fix is the harmony (*l'accord*). Among this sky, this land, and this water there is a necessary harmonious relation, and that is the great difficulty with painting. What interests me less and less in my art is the material side of painting, the lines. The big problem to resolve is how to pull back everything, even the smallest details of a picture, into the harmony of the ensemble, into full agreement.[8]

Pissarro never thoroughly assimilated the neo-impressionist style. He continued to attempt to realize his synthesis through color concord. Seurat's theory sets down more fully how the desired harmony is to be brought about, including more than Pissarro's color harmony.

The year that Seurat exhibited *Chahut*, 1890, a short study on his life and work by Jules Christophe was issued in Paris. The conclusion of the essay presents Seurat's theory on painting as based on a letter written by the artist to Christophe himself. Apparently the text received from Seurat was shortened or edited and the painter was not completely satisfied with the statement as given. In any event we find a new exposition of his doctrines in a letter to the writer, Maurice Beaubourg, dated August 28, apparently 1890:

> In conclusion, I shall record for you the aesthetic and technical note which terminates M. Christophe's work and which is from my hand. I modify it a little, not having well condensed it for the printer.
>
> Aesthetic:
>
> Art is harmony.
> Harmony is the analogy of contraries, the analogy of similarities in tone (*ton*), color (*teinte*), and line considered under the aspect of the dominant one and under the influence of lighting in gay, calm, or sad combinations. The contraries are:

in tone, a lighter, more luminous one in place of a darker; in color, complementaries, that is, a certain red opposed to its complementary, etc. red-green, orange-blue, yellow-violet; in line, those making a right angle.

Gaity, in tone is [gotten] through the use of dominant luminosity; in color, of prevailing warmth; in line, those above the horizontal. ⩔

Calmness, in tone is the equality of light and dark; in color, of warm and cool; and the horizontal for line.

Sadness, in tone is a prevailing dark; in color, a prevailing cool one; and in line, directions downward from the horizontal. ⩙

Technique:

When we admit the phenomena of the duration of luminous impressions on the retina, synthesis imposes itself as a result. The means for expression is the optic mixture of tones and colors (according to the placing and the way the colors are lighted, by sun, oil lamp, gas, etc.), that is to say, the mixture of lights and their reactions (shadows) following the laws of contrast, diminution, and irradiation. The frame is in harmony opposed to that of the tones, colors, and lines of the picture.[9]

Though Seurat calls a work of art a synthesis, it seems apparent from what he has written that it is a sum. To understand it one isolates the elements of which it is composed, much as a chemist would set to work. For the work of art these elements are concrete, visible existents, color, lines, light and shade. One does not prate about beauty or sublimity as the idealists do, for these are metaphysical essences which the scientific aesthetician cannot find. Take the elements which analysis yields, study them, learn how to manipulate them in isolation and in combination and you have the formula for the creation of a work of art. If Courbet had adopted the point of view of positivism, Seurat has adopted its method.

Paul Signac in his book, *D'Eugène Delacroix au néo-impressionnisme*, defines the neo-impressionist painters as " those who have revived and since 1886 developed the

technique called divisionism in employing the optic mix-
ture of tones and colors as a manner of expression." [10]
These painters have been drawn to this manner of painting
because through it they can obtain greater luminosity than
by any other means. On this supposition the book is an
exposition of painting as a scientific technique. Signac is
concerned to show that the method of the neo-impres-
sionists is a realization of the theories of Delacroix and the
impressionists.

The neo-impressionists do not paint in dots, they " do
not ' pointille ' but divide," employing the technique of
little daubs of color because of the necessity of doing so
from scientific principles. Divisionism assures them lumi-
nous, colorful, harmonious effects through

1 The optic mixture of pigments
2 The separation of diverse elements, color, form, light, and their
 reactions
3 The equilibrium of these elements and their proportion (accord-
 ing to the laws of contrast, diminution, and irradiation).
4 The choice of touch proportional to the dimensions of the
 picture.[11]

Signac does not like the word pointillism. It does not
have the overtone of correct meaning. Divisionism, he
thinks, has, meaning " a complex system of harmony, an
aesthetic more than a technique," for " the basis of division
is contrast, and is not contrast art itself? " [12]

With the thrill of the artist who finds pleasure in his
artistry he tells us in one beautiful passage that the painter
takes joy in his instrument of color as the musician in his
orchestration, that he composes with the seven notes of
the color scale as the musician does with the scale of
sound.[13]

Long portions of the work are given over to showing how
the neo-impressionist aesthetic is in the tradition of Dela-

croix. Passages from Delacroix's *Journal* are quoted to emphasize the comparisons. Impressionist theory is discussed for the same purpose. The aim of Delacroix, the impressionists and the neo-impressionists is " to give color the most brilliance possible." [14] Among the three the methods vary and consequently the results. The third group alone fully realized the common aim. " By the suppression of dull pigmentary mixture, by employing exclusively the optic mixture of pure colors, by a methodic divisionism and the observation of the scientific theory of colors, [they] guaranteed a maximum luminosity, coloration, and harmony, which had never before been obtained." [15]

Divisionism is further established by appeal to authority. The scientific work of Rood is quoted and the theories of Ruskin on stippling are called upon to support it.

There are two further ideas which should be noticed. The first concerns beauty. Pissarro and Seurat do not mention the word, Signac only twice. He calls the rules for the harmony and accord of the elements in a painting the rules and principles of beauty. Knowing these rules, he argues, does not make one too technically learned to be an artist, for knowledge of the principles of relationships does not make artists less capable of being moved emotionally or less able to move us.[16] Beauty is not a metaphysical quality which touches the soul, but a quality inherent in physical relationships among various elements. It has no mystery clinging to it and may be presented through measured quantities. A new path is being followed here. An embarrassing term of realist aesthetics is given a scientific definition.

The second idea is more important for it touches upon the relation of the work of art to nature, of the picture to the model. Signac refuses to make the artist the slave of his model:

The divided touches of the neo-impressionists are the artifices these painters use to express their particular vision of nature. . . . Does a painter render a more beautiful homage to nature in striving, as the neo-impressionists do, to re-establish upon the canvas her principal essential, light, or in servilely copying the least blade of grass or the smallest pebble? [17]

The artist does not depart from nature, but he strives to give her fundamental aspect. For the neo-impressionist as for the impressionist this is the sensory aspect of light.

The three statements of theory presented here are clearly of unequal merit. Pissarro's letter of 1886 is too sketchy and general. Signac deals almost exclusively with divisionism, treating it as a scientific technique and being concerned with establishing it as a traditional method. Both men look to Seurat as their leader. His exposition is the clearest.

It is also easy to note outstanding variations among the three statements. Pissarro in 1904 admitted his interest in the material side of his art, the lines, had decreased. Signac makes little mention of linear harmony, referring only to the laws of line which are obviously copied from Seurat. Seurat gives as much attention to line as to color. Pissarro depreciates execution; Seurat presents the aesthetic and technique as interdependent.

These differences are minor. Neo-impressionism as a single theory is clearly demonstrated by the fact that all three of its apologists rest their theory on three fundamental suppositions:

1 The aesthetic value of a work of art lies in its internal harmony of simple elements.
2 This internal harmony can be made explicit by an analytic aesthetic.
3 The painter may achieve this harmony by the application of a scientific technique.

Good painting to the neo-impressionist is the bringing together of disparate elements to fuse them into a harmonious unit. Its process is twofold. The painter first subdivides and classifies the elementary parts of his pictorial composition. The subject to be painted is analyzed as composed of colors, lines, and tones. These elements are then joined into a pattern in a painting, and the contextual unity of these parts gives the aesthetic quality of the work, its beauty to which we normally respond. This is so because it would seem that the quality of the elements themselves as well as the manner in which they are used have each corresponding emotional states constantly and universally associated with them. There are definitely discoverable laws of association between colors, lines, and tones on the one hand and psychological reactions on the other. For instance, gaiety, calmness, and sadness are expressed by a dominating use of lines above the horizontal, along it, or below it respectively. Now these seemingly dogmatic statements were probably arrived at quite empirically through experimentation in the studio with certain color and line patterns for certain desired results. Psychological studies substantiate the contention that certain colors and lines give rise to certain responses within statistical limits.[18]

Yet for all this, to tell what harmony is by giving the conditions under which it is brought about does not make the proposition that the aesthetic value of a work of art lies in its harmony any less a gratuitous assumption. To state the objection in another manner, though we may learn through our analysis that a good work of art may have the harmony and contrast of line, tone, and color that Seurat has formulated for us, we cannot be sure a work is a good work of art because it has those qualities and relations. The proposition is not convertible. You may en-

lighten me about all the technical problems which have been solved in a painting, you may explain to me the relationship of lines, colors, volumes in it, moreover, we may even agree that the particular painting has appeal; but your demonstration cannot show me that the appeal is the result of those solved problems and those relations. It is possible to attribute the appeal to other reasons, and to declare also that other paintings in which the harmony is equally well got make no appeal. Many good painters have done bad pictures. Aesthetic value is not the resultant of good painting technically speaking.

The error here is one that was general in the nineteenth century. It is the error of associational psychology and the representative theory of knowledge, which tried to explain our mental processes and knowing activities by analyzing them as the sum of certain units of sensation. It was an error that William James pointed out in psychology. No sum of elements ever yields us a qualitative totality. The quantitative whole is the sum of its parts, but the quality of the whole is not the sum of the qualities of the parts. Water is chemically hydrogen and oxygen, but the wetness of water is not the sum of the properties of hydrogen and oxygen. Water is wet and puts out a fire; hydrogen and oxygen are not wet, and the one is necessary, the other an aid to combustion. The situation is similar when we turn to meaning-situations. A sentence is the sum of the words that make it up, physically speaking, but the meaning of the sentence is not the sum of the meaning of each word. The sentence has its own meaning. And frequently, too, the meaning of a context will change or alter the meanings of words within it. A work of art also with its elements is in an analogous situation with reference to emotional responses. But in the nineteenth century analysis was the recognized method of science, and the

method of science had borne fruit wherever it had been applied. It was reasonable to expect it would do so for intensive qualities as well, and the new aesthetic analysis was diligently pursued by Seurat and those who followed the neo-impressionist beliefs.

With the neo-impressionists aesthetics is supplanted by the science of art. Aesthetics had approached art through speculation on the nature of the beautiful. The science of art examines the object of art and the elements contained in it to arrive at generalized laws of the nature of art. German theorists like Zimmermann and Fiedler had made the science of art a study of schemes of pure visibility. The neo-impressionists explained art as a visual scheme of formal relations. The analysis in both cases is positivistic. Taine had also worked along the same line when he made his aesthetic study a philosophy of art. The difference was only in his explanatory methodology. He had undertaken his analysis on the basis of the elements that contribute to the artist's make-up, the trinity of time, place, and race. But he had failed to limit his study to elements visible within the work itself and this was where the neo-impressionist aesthetic was more positivistic than his. The new aesthetic is coming to the conviction that the sum of what we can know about art is in the work of art itself. We stand at the threshold of the autonomy of art.

The neo-impressionist is well aware of this. In his theory the relation between art and nature begins to break. If nature does not present itself to our sight in divided touches,[19] where do we make the transition from nature to art? The principal quality in nature that painting can render is light. The artist starts with his vision of nature but to create a work of art he must proceed thenceforth according to the rules of art itself. " Never in nature could the artist discover its rigorously integrated design; nature

to him merely furnishes the data from which to select and invent." [20] Color arrangements and line compositions are coming to be valued for themselves. The free beauty of formal design is coming into its own. Signac correctly senses the affinity of painting to music.

So, within forty years after the inception of realism painting had advanced along the general path that Courbet had marked out in following scientific procedures. But in so doing it began to doubt the realist theses, for it found the relation of nature to art a problem not a solution, and one that was to be crucial to the artists of the next fifty years.

NOTES

[1] E. Moreau-Nélaton, *Manet raconté par lui-même*, vol. II, p. 95; originally in the *Grande Revue*, August 10, 1907.

[2] *Ibid.*, p. 96.

[3] H. Focillon, *La peinture du XIX^e et du XX^e siècles, du réalisme à nos jours*, p. 200. The same general point of view is expressed by L. Venturi in *Les archives de l'impressionnisme*.

[4] Cf. P. Signac, *D'Eugène Delacroix au néo-impressionnisme*, p. 59: " It is in 1886 that there appeared works painted by a reasoned method."

[5] Michel-Eugène Chevreul (1786-1889), French chemist, did extensive work on the theory of color as Director of the Gobelin Tapestry Works. He was the author of an important work, *De la loi du contraste simultané des couleurs*, 1839.

[6] Ogden Nicholas Rood (1831-1902), American physicist, made extensive studies on the quantitative analysis of color contrasts. His principal work is *Modern Chromatics*, 1881.

[7] Given in Venturi, *op. cit.*, vol. II, p. 24.

[8] Robert de la Villeherve in the *Havre-Éclair*, Sept. 25, 1904; in Venturi, *op. cit.*, vol. I, p. 101.

[9] R. Rey, *La renaissance du sentiment classique*, reproduction facing pp. 132-133; also in G. Coquiot, *Des peintres maudits*, pp. 132-134 with minor exceptions. Cf. Rey, *op. cit.*, L. Cousturier, *Seurat*, and J. Rewald, *Seurat*, for Seurat's manifesto.

[10] P. Signac, *op. cit.*, p. 1.

[11] *Ibid.*, pp. 4-5.

[12] *Ibid.*, p. 79.

[13] *Ibid.*, p. 82.

[14] *Ibid.*, p. 87.

[15] *Ibid.*, p. 88.

[16] *Ibid.*, pp. 106 and 107.

[17] *Ibid.*, pp. 83-84.

[18] *Vide*, e. g., K. Hevner, " Experimental Studies of the Affective Value of Colors and Lines," *Journal of Applied Psychology*, Aug. 1935, pp. 385-398.

[19] Yet in the theory of Helmholtz nature does so present itself to us. He distinguishes three kinds of nerve fibres, each responding to one of the pure colors, red, green, and violet. The sensation of a color, therefore, depends upon the changes occasioned in these fibres by the external stimulus.

[20] D. C. Rich, *Seurat and the Evolution of " La Grande Jatte*," p. 15.

THE GREAT INDEPENDENTS: RENOIR AND CÉZANNE

PAINTING was not to follow the ways of scientific realism without a vigorous denial from some artists. This denial could take two forms. In the first place, one could repudiate any connection between science and art and disregard the problem of the relation of the work of art to the natural object. In the second place, one could go on to a deeper probing that would modify the positivistic viewpoint and result in a new conception of the relation between the world of art and the natural world. And it would mark a new point of departure in modern aesthetics. The first was the way of Renoir. The second was that of Cézanne. Both men were great enough painters to pursue their own individual ways. And in their theories they never descended to the dogmatic limits which define a school. Renoir steadily fought against schools. Cézanne was too possessed with the analysis of his own aesthetic to fall into such a groove.

The first of Renoir's writings that we have are two articles which appeared in Rivière's *L'impressionniste* in 1877, signed *un Peintre*. Why is it, he asks in the first of these, that the architecture of today does not have the beauty of the older buildings? The old Louvre is beautiful the new one is not. He ventures the answer that it is because the ornamentation on the new is heavy, banal, and the work of laborers, that on the old is light and the work of artists.[1]

His answer betrays a belief that beauty is a kind of decoration superadded to life. This is in keeping with the

impressionist concern with surface appearances only. The beauty of architecture is not its functional value, but is the decorative arabesque that plays over façade and walls.

"The architect should be an artist more than a savant"[2] is the burden of the second article. *L'École des Beaux Arts* education has made copyists of architects, sculptors, and painters. Such a school should be suppressed. Until a new generation of architects comes to reverse affairs with a new education, the direction of architectural monuments should be given to painters, he claims.

Though French painters had fulminated against the academic teaching of the popularly accepted schools of the nineteenth century, *beaux arts* architecture was not subjected to widespread criticism until later. The eclecticism of the schools was generally accepted, or at least dominated architectural practice, until the end of the century. True there were men like Labrouste, who thought of architecture as building in forms that met the new social demands and employed new materials, but their work was the rare exception. Renoir is making a plea for the architect as a creator, not as a copyist of styles. It is significant that he is among the earliest of those who fought the false training of the schools. The very fact that these articles were the work of a painter and not an architect demonstrates the healthy influence of the new revolt in painting on the other arts. Furthermore, they show that the revolt against *beaux arts* architecture had been in gestation since the early days of the Third Republic.

In 1884 Renoir drew up the program of irregularity, opposing the traditions of academic painting and the stereotype art which the public was accepting. Its greatest virtue is its simple statement of what seems obvious:

Nature abhors a vacuum, say the physicists. They should complete their axiom by adding that it has no less a horror of regularity.

Observers know in effect that, in spite of the apparent simplicity of the laws which preside at their formation, the works of nature are infinitely varied, from the most important to the least, of whatever type or kind they are. The two eyes of the most beautiful face will always be the least bit dissimilar; even the nose is not found exactly placed over the center of the mouth. The sections of an orange, the leaves of a tree, the petals of a flower are never identical. It seems that the beauties of every order draw their charms from diversity.

Upon examining from this point of view the most renowned plastic or architectural reproductions one can easily see that the great artists who have created them, careful to proceed like nature of whom they are always respectful pupils, are on their guard never to transgress its fundamental law of irregularity. It is even proved that works based on geometric principles don't present one line of perfect exactness, and what round, square, or oval figures there are which could easily have been made exact, are never so. Thus one can without fearing error affirm that every really artistic production has been conceived and executed according to the principle of irregularity. In a word serving us as a neologism to express more completely our thought [we may say] that it is always the work of an irregularist.

At this time when our French art, [which was] so full of penetrating charm and exquisite fantasy at the beginning of this century, is going to decay because of regularity, dryness, and the mania of false perfection that is tending to make the unadorned cleanness of the engineer into an ideal, we think it useful to react promptly against the moral doctrines which threaten to annihilate it. We also think it is the duty of all sensitive people and men of taste to join together without delay regardless of what may be their repugnance to struggle and protestations.[3]

An association of artists dedicated to the principle of irregularity is necessary, he continues, and the condition of admission to it for architects would be that they render their ornamental motifs according to nature and without precision instruments.

Such a program divorces art from the mechanical craftsmanship that had become the popular ideal in the nineteenth century and from repetitious formulas. It makes freehand spontaneity the basis for art. That art should

strive to be irregular in this sense may seem an innocent statement. But it must be recalled that from the time of Plato there had been the tradition that true beauty is the beauty of geometrical figures.[4] In the eighteenth century the love for natural landscape, the cult of the picturesque, and the Gothic revival indicate a change to an interest in variation. This change is found in the love for the exotic, the great admiration for Chinese art, architecture, and gardens. This is the taste that Renoir was bred in when he decorated fans in his youth.

The functionalism of the engineer, whose bridges, factories, expositions buildings, and department stores were becoming numerous at the time Renoir wrote, was " regularist " and contrary to his taste. The unadorned, clean beauty of such buildings repelled him. He did not see that in the crude, machinelike buildings of the engineer was the new force that would sweep away the old *beaux arts* traditions and clear the ground for a new architecture.

Renoir was concerned only with a very small problem raised by the conditions about him. The end of the nineteenth century saw a general bankruptcy of taste and the substituting of moralizing and electicism to justify the opulence of life and the acceptance of middle class values. To the average taste of the time any work of art was good by virtue of its applied ornament and its decorative appeal. The quality of the decoration was not questioned. We must at least admit that Renoir raised his voice in favor of good craftsmanship and good taste in decorative design.

Renoir's attitude was that of those who helped to bring about the new style in decoration at the turn of the century known as *l'art nouveau*. Inspired by the crafts movement of William Morris in England who revolted against the poor taste of his day, the arts of design experienced a minor renaissance. There was a revived interest in good

craftsmanship that is bearing admirable fruit today. Going to nature for their models the artists of *l'art nouveau* employed graceful curves, swirling spirals, plant and animal forms with supposed imaginative freedom in furniture, metalwork, jewelry, architectural accessories, and painted decoration. *L'art nouveau* was the embodiment of Renoir's principle of irregularity. But the movement was doomed to an early death for the artistic value of a work can scarcely lie in so weak a principle.

Renoir also wrote a preface to an edition of Cennino Cennini's *Livre de l'art*.[5] This preface has been called " Renoir's testament " which affirms " on each page his faith in the classic tradition," [6] a statement that is certainly exaggeration.

We are liable to forget the past, Renoir tells us, because so many recent marvelous events and discoveries turn our eyes from what happened prior to them. But a glance back at this past is not a useless procedure for us today, and in a man like Cennini we are amply rewarded. Besides being a technical manual, the treatise of Cennini is a history from which we can learn much about art. The artistic greatness of a nation is not measured by the few works of a man of genius but by all the works of all its artists. It was to all artists of his time that Cennini spoke, his purpose to make good artisans.[7]

Renoir reiterates the proposition of the realists: " One would not know how to live outside of his time. . . ." [8] The times of Cennini and our own, Renoir says, differ in two important respects which make our own artistically inferior. Painters could then engage in collectivistic activities, that is, several might decorate one church and yet among their individual works there would be a unity for " the painters would possess the same *métier*." [9] Painters then learned their trade through apprenticeship, through

initiation little by little into the actual practice of their
art. Yet such apprenticeship did not kill the originality
of those painters: Raphael was no less himself for being
the pupil of Perugino. This spirit of the *atelier* is gone
from art today. The second factor which explains the
great value of past art is religious sentiment, that har-
monizing agent which moved among all men and the age
in which they lived. Though religious sentiment has
steadily grown weaker the rules established under its in-
fluence have kept art on a high plane where Catholic
culture has prevailed. Even in the time of the greatest
power of the Church the artists were relatively free.
" Faith was the regulator of their fantasy which could
nourish itself without fear from profane sources." [10] Today
we are not in that happy situation:

> Gods are no longer wanted, and gods are necessary to our imagina-
> tion. It must be confessed, modern rationalism, if it is able to satisfy
> the learned, is a manner of thinking incompatible with any conception
> of art.[11]

Beside these two factors there is a secondary cause for the
decadence of art today. Formerly one worker would carry
one object to completion himself, and thus the work would
be a product of his own interest and intellectual joy in the
solution of the problems it presented. But today the
division of labor, servile repetition, *machinisme* has sup-
pressed this joy. The artist has forgotten his ideal: " The
most skilful hand is always only the servant of thought." [12]
One may learn to make clever works in the modern art
school, but he will never make a work of art until he can
enliven his work with this great ideal of craftsmanship
which makes the painter subject to the same rules of
mètier as the carpenter or the iron worker.

Here, as in 1877 and 1884, the quarrel of Renoir is with

inadequate craftsmanship. To work by rule is *machinisme* but art is not encompassed by precept and logic. What is made by rule does not have spontaneity; it is a copy. And that which can be wholly known by reason is not art. The lesson of the history of art is that works of art cannot be produced by the methods of the schools for that which makes the old art great is precisely what we can never know by rules. It is the human quality found in the religious sentiment of the painter of the Renaissance, or in the joy he took in his work. Great art is not imitation, and being itself indescribable, is inimitable.[13] The artistic quality in a work of art is something inherent in each work. Irregularity is the principle of vitality as opposed to mechanism. No theory is capable of describing what a work of art is. No rules can tell us how to make such a work. One may say that the painter must strive to perfect his craft and that he must put himself in the tradition of great art, but specifically how he is to do this cannot be told. It is a matter of the feelings or intuition of the artist.

This is the admission that art is inexplicable. " If they could explain a picture it wouldn't be art," [14] Renoir is reported to have said. Courbet had made artistry something definite, copying the beauty of nature, the plainness of homely objects simply intuited and recorded. The neo-impressionists had reduced art to a formula of harmonic relationships. There was no mystery which need be concealed under the word " intuition " for all was open to analysis. With Renoir painting becomes instinctive again. Good artistry is akin to the craftsmanship of the Renaissance painters. One paints with a feeling of inspiration like a religious sentiment, and one takes joy and deep interest in his performance. And the works which one produces reflect this gaiety and lifelike exuberance. Teaching cannot give this quality to a work of art and theory will never

describe it. If ever any artist believed the painter should have no program, no conscious theory, it was Renoir. Art is instinct, and categorical theorizing cannot describe instinct.

The philosophical parallel of Renoir's theory is the Bergsonian metaphysics. In the division of reality between time and space, that which is living is found in the first category, that which is inorganic in the second. Life has a dynamic urge, an *élan vital*, which propels it through time and which brings to fruition all the multiple variations of living things, the irregularities of nature which Renoir talks about. Reason is the power by which we know the world of space; intuition, our inner feeling, is the principle by which we perceive the world of time with its living movement. Reason gives us relative knowledge, intuition gives absolute knowledge. The first is symbolical, linguistic description, presenting only a limited phase of an object. It is never complete. Intuition, on the other hand, is immediate and direct. We sympathize with the object and know it " from within." Symbolical knowledge is analytic, it breaks up the object; intuition gives knowledge of the object as a unit. Symbolical knowledge is abstract, scientific. In intuition we identify ourselves with the object of knowledge by imaginative effort. It is possible to pass from intuition to analysis but not the other way. Intuition is the intellectual sympathy by which one knows the inexpressible, the meaning of a poem, the beauty of art. Art belongs to the world of time, and reason is dumb before it. Theory can not explain art, for theory is the work of reason and a work of art is the spume of the intuition. Art is indescribable, so reason cannot reach it; it is inimitable, so reproduction will not give the copy that quality which belongs to aesthetic sensibility.

In art man makes use of intelligence because he makes

choices and works towards purposes. In artistic technique the hand becomes the servant of thought, he settles those problems of his craft which arise from the difficulties of his medium by the application of rules. Yet in all this the intelligence is kept subordinated to intuitive desires. " I arrange my subject as I want it, then I go ahead and paint it like a child. I want a red to be sonorous—to sound like a bell; if it doesn't turn out that way I put on more reds or other colors till I get it." [15] When art belongs to Bergsonian intuition how else could one explain his painting? The painter must seize the rich multiplicity of natural forms and translate the life of the organic world to his canvas. The flesh on his canvas must be alive.

In his concern with spontaneity Renoir never once considers the realist's problem of the relation of the picture to the model. It is a false problem to one who denies that the artist should follow the suppositions and techniques of the positivist aesthetic. The world of the intuition has nothing to do with art as an imitation of outward natural forms. Cézanne, however, faced the problem and gave it thought, hence became the fountainhead of early twentieth century developments. He, too, did not have a clear-cut theory, but that is because his ideas suggest how much a theory of painting depends upon psychological and epistemological foundations.

For many years Cézanne worked in retirement trying to realize his conceptions, his work unknown at public exhibitions and seen only by the artists who frequented the shop of Tanguy, dealer in oils. In a letter to Octave Maus, leader of the Belgian *Vingt*, Cézanne voiced the reason for his retirement:

I have resolved to work in silence until the day when I shall feel myself capable of defending theoretically the result of my attempts.[16]

By a theoretical defense he never meant dogmatic rules of art. He wanted an explanation of what he was doing that would satisfy himself and explain his art to others. He wanted a statement of his personal way of painting when that manner had crystallized to his satisfaction, not a formalistic theory. That such is the case may explain why his theory was never fully set forth in a single document, but is found in scattered passages in his correspondence during the last four years of his life.

In 1878 he had written to his friend, Zola, that painting was a means of expressing sensation.[17] This was a lifelong belief to which many a letter bears witness.[18] In sensation we make our contact with nature, and in nature art finds its subject matter. Cézanne started with the position of the impressionists to whose group he once belonged.

Yet one must also recognize that there is the problem of the technical adjustment of the natural model to the demands of the artistic expression:

In art above all everything is theory developed and applied on contact with nature.[19]

Now if a strong sensation of nature—and certainly I have a lively one—is the necessary basis of all artistic conception, and the basis on which the grandeur and beauty of the future work reposes, knowledge of the means of expressing our emotion is no less essential and is acquired only through a very long experience.[20]

But sensation is not a simple thing, as the impressionists had thought. Nature is a diversified and complex model and one cannot be merely submissive before it.

I proceed very slowly, nature showing herself to me as very complex; and the progress to be made [in understanding her] is endless. One must see one's model very well and feel it very forcefully, and still more, express it with distinction and force. . . . The real and stupendous study to be ventured is that of the diversity of nature's picture.[21]

Cézanne is never the slave of his model, but goes to nature to depict her according to his own artistic vision:

> But I always come back to this: the painter ought to dedicate himself entirely to studying nature, and should endeavor to produce pictures which are a lesson One can't be too scrupulous, too sincere, or too submissive to nature, but one ought to be more or less master of his model and above all of his means of expression. Penetrate what is before you, and express yourself as logically as possible.[22]

Cézanne denies that the visual sensations are primarily of the luminous surface of bodies. It is not light and color we perceive; rather, these are the forms under which we perceive receding planes. The painter is concerned with depth, the plasticity of nature:

> I wish to say that in an orange, an apple, a bowl, a head there is a culminating point, and this point is always—in spite of the terrible effect: light and shade, colored sensations—drawn closest to the eye [when] the borders of objects flee towards a center placed at our horizon.[23]
>
> An optic sensation is produced in our visual organ, which makes us class by light, half-tone or quarter-tone, the planes represented by colored sensations, (light does not exist, therefore, for the painter). Insofar as you go forcibly from black to white, the first of these abstractions being like a fulcrum as much for the eye as for the mind, we daub and do not succeed in having our freedom, in being masters of ourselves.[24]
>
> Now the colored sensations which give light are the cause of abstractions which prevent me, an old man about seventy, from covering my canvas and from pursuing the delimitation of objects when the points of contact are tenuous and delicate, from which it is implied that my image or picture is incomplete. In another way the planes fall one upon the other, from which neo-impressionism arises, which circumscribes the contours with a black stroke, a fault which it is necessary to combat with all force. Now nature, when we consult it, gives us the ways for attaining this purpose.[25]

Truly Cézanne has made impressionism something solid.

The principle under which the artist orders his perceptions is recession from the eye. From this he perceives volumes in depth, overlapping planes, and the blue effect of aërial perspective. These are the elements he can adjust on his pictorial surface. In a famous passage he announces this:

> Permit me to repeat what I said to you: treat nature by the cylinder, the sphere, and the cone; the whole placed in perspective, let each side of an object or a plane be directed toward a central point. Lines parallel to the horizontal give extent, whether it be a section of nature, or if you prefer, some spectacle which the Omnipotent Father, Holy God, spreads before your eyes. Lines perpendicular to this horizon give depth. Indeed, nature for men is more a thing of depth than of surface, whence comes the necessity of introducing in our vibrations of light, represented by the reds and the yellows, a sufficient sum of blues for the air to be felt.[26]

These passages show quite clearly how Cézanne was reacting to the neo-impressionist aesthetic and turning to the western tradition of perspective, both linear and aërial, to correct its errors. They also show him grappling with our recurrent problem of the relation between the natural and the pictorial world. To him nature and art are connected but not in the strict model-copy relationship. Nature supplies the grounds for art, whose business it is to comment on the natural world within the limits of its own possibilities, not to copy outward appearances. The basis of such a procedure is sensation. The positivistic point of view of realism and impressionism is still the determining influence here, but new factors have entered. The realist preoccupation with exact imitation of nature raised the question of what is nature. One may say, " open your eyes and look," but the course of painting from 1855 to 1889 had shown that nature may be several things. It may be rural and social simplicity and that part of the world which the average person calls unpleasant. It may

be the physical surface of objects in their iridescence. It may be any organized, arranged pattern, or it may be irregularity. The data of sensation are in the natural world, but for the artist these data are selected, determined by the principle which governs his conception of what painting can or should do. The realists, the impressionists, Renoir, all had conceived of the natural world which art presents as some form of surface quality. They had not completely broken with the superficiality of the July Monarchy and the Second Empire, with satisfaction in ornament, with the positivistic point of view. Cézanne was trying to make the nature which art describes something more essential, something closer to physical reality. He was trying to establish for that nature a principle which did not derive from the perception of accidental qualities. He was trying to find the primary qualities for the nature which art knows as the Renaissance philosophers had tried to find the primary qualities of the nature which physics knows when they gave up sensible qualities in favor of mathematical qualities. And these primary qualities which nature displays for painting, Cézanne declared were volumes and the recessive juxtaposition of planes as given in linear and aërial perspective. All the means open to the painter are subordinated to the purpose of giving more adequate expression to the density of nature. Color is a means of representing volumes; light and shade also. The nature of the painter is as much an abstraction as the nature of the physicist. Now when sensation yields the world of volumes expressed in painting, the positivist position would appear to be injected with an element of the intellectual. Plastic organization cannot come from simple passive sense perception, but only from a reorganization of nature, treating it according to certain hypothetical constants (receding planes, volumes, atmospheric perspec-

tive). The precept about the cylinder, the sphere, and
the cone is not a rule for the representation of objects, as
it was later tortured by the cubists to signify. It specified
the manner, the presuppositions under which the artist
was to approach nature.

Cézanne had raised and settled to his own satisfaction,
at least insofar as it affected art, the ever recurring philo-
sophical question of how much of what is given in sense
perception is to be attributed to the external world and
how much to our own intellectualizations. It has been
said that the theory of Cézanne lets " vision appear in its
sensible purity." [27] But what is the sensible purity of
visual sensation? Things do not look to us as they do
solely because of what they are. We do not passively re-
ceive simple sensations which, by separate mental actions
of interpretation, are changed into perceptions. The ap-
pearance of objects depends upon the total visual field in
which they are found, and upon definite attitudes and
experiences, in short, upon the total organization of the
observer. Now our visual environment may consist, let us
say, of chairs, tables, and apples, or it may consist of
cubes, rectangles, and spheres. To whichever class the ob-
jects of our environment belong depends upon their rela-
tionship to our activities. The objects are " functional
characters " of our designs upon them. They are chairs if
we wish to sit in them, apples if we wish to eat them. The
objects that we look upon as objects to eat are also decora-
tions if we place them along with other fruit in a dish on a
sideboard; they are something which secure our personal
tenuous economic well-being if we have grown them to sell,
and we immediately translate them into monetary terms;
they are colored spheres if we wish to paint them. Which-
ever way we " see " them depends upon our assumed
mental attitude toward them resulting from some behavior

we wish to take regarding them.[28] The hungry man, the farmer, the artist, etc. each has his own " categories " under which he subsumes these objects, and these categories are each dependent upon the other. This is the assumption Cézanne is making when he talks of treating nature as volumes and planes. Hence when he insists that the artist should approach nature through sensation, this sensation is predetermined as one which will yield him the object under the assumed artistic category. It cannot be claimed that sensation is pure or can be considered apart from abstraction. Sensation by its very nature and purposes includes the second, and is not something prior upon which abstraction works. The distinction between the two is mental. Even if sensation were a pure and simple thing it could not account for the difference between the aesthetic object and the natural object, or the way in which the natural model is adjusted to the demands of two-dimensional representation.

The aesthetic object is a hypothetic object. It arises as relative to a natural model and to a painter's intent as that is qualified by his medium. In the adjustment of the natural model to the pictorial demands there seems to be an assertion of the autonomy of art. In the continual insistence on a reference back to nature Cézanne qualifies that assertion. In his aesthetic the perceptions and abstractions of the artist are placed on an equal level with mathematical thought and logico-scientific procedures, methods to which alone the world had given priority from the seventeenth to the nineteenth centuries.

The theory of Cézanne like his painting was destined to be developed in two directions, one way by the cubists and intellectualists, the other by the fauves and expressionists.

The analogy of Cézanne's idea that artistic creation depends upon the acceptance of an ordering principle of

sensation and Poincaré's demonstration of the reason for hypotheses in scientific method is a striking example of similar trends of thought occurring in disparate fields. Both began on a positivistic basis, Cézanne assuming that the artist limits his art to the expression of his experience of nature; Poincaré, the physicist, recognizing as legitimate explanation only the descriptions of empirical sciences. Yet each affirmed that within the rendition of his experience there was a subjective element. To Cézanne nature was so diversified that the artist must have some principle by which he orders his sensations of it. This principle was depth, and it determined what the artist was to see in nature. And to Poincaré the scientist adopts his hypotheses in view of the principle of greater simplicity and consistent application. Such a principle is not only practical but is also aesthetic; the hypothesis adopted meets the scientist's taste for neatness. His principle enables him to schematize the materials of knowledge as the artist's enables him to organize his complex sensations.

The formulation of Einstein's relativity hypothesis, by which simultaneity depends upon an assumed point of reference; the rise of polytonality in music, in which two keys are employed simultaneously but the harmony is dependent upon a principle of overtone relationship among the tones occurring at any moment; the development of symbolic logic, which formalizes the old logic of class-inclusion and the logic of propositions, are further evidences of a general trend to new schematizations in the sciences and the arts at this time.

With Cézanne the practice of art is raised from a concern with realistic rendition to an intellectually and sensibly modified transcription of the natural world. And the aesthetics of painting assumes the attitude of a critical positivism which is careful of its own methodology and is

aware of the problems of psychology and epistemology within itself.

NOTES

[1] Articles quoted in Venturi, *Les archives de l'impressionnisme*, vol. II, pp. 321-322, 326-329.

[2] *Ibid.*, p. 328.

[3] *Ibid.*, vol. I, pp. 127-129.

[4] Cf. Plato, *Philebus*, 51c.

[5] Cennino Cennini, Florentine artist, wrote a technical treatise on painting about 1400. A modern French translation appeared under the title, *Livre de l'art*, prefaced by a letter from Renoir to the translator's son, Henry Mottez, who published this edition. The date of Renoir's letter is doubtful, though probably in his last year. The letter is given in R. Rey, *La renaissance du sentiment classique*, pp. v-xii. Letter is hereinafter referred to as *Lettre à H. M.* Translations are quoted from this letter by the kind permission of Art Catholique, copyright holders of Victor Mottez' edition of C. Cennini, *Livre de l'art*.

[6] Rey, *op. cit.*, p. 58.

[7] Cf. *Lettre à H. M.*, p. vi.

[8] *Ibid.*, p. vii.

[9] *Ibid.*, p. viii.

[10] *Ibid.*, p. x.

[11] *Loc. cit.*

[12] *Ibid.*, p. xii.

[13] Cf. W. Pach, " Pierre Auguste Renoir," *Scribner's Magazine*, May 1929.

[14] *Ibid.*

[15] *Ibid.*

[16] P. Cézanne, *Correspondance*, ed. J. Rewald, p. 214, letter dated 11-27-89.

[17] *Ibid.*, p. 153, to Zola 11-20-78.

[18] Cf. ibid., p. 227, fragment, 1896; p. 288 to his son 9-8-06; p. 297, to his son 10-13-06 and 10-15-06, and in following passages quoted.

[19] *Ibid.*, p. 253, to Chas. Camoin 2-22,03.

[20] *Ibid.*, p. 257, to Louis Aurenche 1-23-04.

[21] *Ibid.*, p. 261, to Bernard 1905, also p. 238, to his son 9-8-06.

[22] *Ibid.*, p. 262, to Bernard 5-26-04.

[23] *Ibid.*, p. 265, to Bernard 7-25-04.

[24] *Ibid.*, p. 269, to Bernard 12-23-04.

[25] *Ibid.*, pp. 276-277, to Bernard 10-23-04.

[26] *Ibid.*, p. 259, to Bernard 4-15-04.

[27] L. Venturi, *Cézanne*, vol. I, p. 53.

[28] For the complete presentation of the psychological argument here briefed cf. K. Koffka, *Principles of Gestalt Psychology*, especially pp. 75-105, 129-164, 392-394.

SYMBOLISM AND FAUVISM: GAUGUIN, DENIS, MATISSE

IN REPUDIATING the validity of a connection between science and art Renoir had limited his critique to machinism, and had declared that art is the result of sensibility. An attitude that completely divorced art and science was voiced by those men who talked of primitivism, the intuition, and expression.

In rebellion against the analytic aesthetic of neo-impressionism, Paul Gauguin and a group of friends initiated about 1888 the style of painting later to be called symbolism. The superficial characteristic of the style was a complete change from broken brushwork to smooth and unvarying application of color to a definite area of canvas, much like a block print in effect.[1] Behind this technique there was a developing aesthetic. Gauguin and his friends exhibited as a group at the Paris Exposition of 1889 in a café on the grounds known as the Café Volpini. The pictures were in white frames, and the announcement proclaimed they were painted by a group calling themselves the symbolists or synthetists. Later the painters, Émile Bernard and Paul Sérusier, separated from the group and from that time Gauguin spoke of these only as the symbolists.[2] Similar groups later came into being with different variations on the original aesthetic, the *nabis* with Maurice Denis, and the *Rose Croix* painters. However, their theories of art are similar enough to warrant using the term symbolism as generic for all of them.

In the many journals and letters written by Gauguin there are numerous allusions to art.[3] Here one finds incipient the principles of symbolism in Gauguin's identifica-

tion of his exotic art with his escape to the exotic life. The first is the symbol of the second. To Strindberg he writes:

> Civilization is what you suffer from; to me barbarism is a rejuvenation. Perhaps the memories of your selection have evoked [for you] a painful past when confronted with the Eve of my choice, which I have painted in the forms and colors of another world. This world, which neither a Cuvier nor a botanist would possibly recognize, will be a paradise of which I alone have made the rough draft. And from the rough draft to the realization of this dream is far. But what matter! To catch a glimpse of blessedness, is not that a foretaste of *nirvana?* [4]

Such was his reply to the great dramatist who with realist concern had doubted the barbarity, the torturedness, and the anti-literal painting of such works as *The Spirit of the Dead Watching.*

Gauguin fled to the islands of the Pacific because he believed that in the simple life of the primitive of his day one finds again man's true nature which has been lost through civilization. This yearning to return to a " natural state " where man once had his bliss is the stuff of all primitivisms. It has existed in a thousand forms since the beginning of history, for nature like beauty is not a single thing. Each race has its myth, each society its interpretation. There is the legend of the natural state of man in the Garden before the fall. There is the legend of a past golden age before troubles and evils came into the world. Nature has meant the state of the " noble savage," or the Petit Trianon and a milk-maid's costume. A romantic love for the exotic confuses that which is primitive in place with that which is primitive in time. It is assumed that those peoples who live untrammeled by the economic and social artificialities of occidental civilization have retained that desired quality of the childhood of the race. This quality they display in their works of art, and whoever would

strip from his own art the inhibiting accretions of civiliza-
tion must make his work like theirs, not only in appear-
ance but in the strong feeling for the simple which is
incorporated in them. One who is a primitive in life is
thus the better able to be a primitivist in art. The works
of art he gives us will correspond to the emotions and
joys he experiences in his adopted life.

For Gauguin the work of art was also the symbol of his
own emotions: " The work of art for him who can see is
a mirror wherein is reflected the state of soul of the
artist." [5] He carried into his art all the pathetic emotion-
alism that led him to attribute to the life of the Poly-
nesians a happiness not to be found in Europe. In this he
was distinctive. True, artists before him had found in-
spiration in far places and distant times. The eighteenth-
century interest in Chinese art had been reflected in Eng-
lish gardens and Chippendale furniture. Delacroix had
found new motifs in Algeria. Whistler and the impres-
sionists admired and copied Japanese color prints. David
and Corot had looked at Rome with a certain nostalgia.
The Pre-Raphaelites had set their eyes on the Italian
primitives. But all these attempted to translate the past
into their own times, or to imitate the strange. Gauguin
had reversed the process: he retreated from the milieu in
which he was born to an elsewhere that he thought
incorporated the past.

Since the primitivist sees perfection in the past he is
thereby opposed to the positivist who believes in an evolu-
tionary progression to a perfect state of the future. The
former is thus opposed to modern scientism, and in paint-
ing he disparages realistic techniques. Gauguin states the
point of difference in his criticism of the impressionists:

They pursued their searches in accordance with the eye and not
toward the mysterious center of thought, and consequently fell into
scientific rationalizations[6]

The mysterious center of thought or state of the artist's soul is inexplicable. It is only through works of art that one experiences it:

> There is an impression resulting from any certain arrangement of colors, lights, and shadows. It is what is called the music of the picture. Even before knowing what the picture represents—[as when] you enter a cathedral and find yourself at too great a distance to make out the picture—frequently you are seized by this magic accord. Here is the true superiority of painting over other forms of art, for this emotion addresses itself to the most intimate part of the soul.[7]

In art color symbolizes this interior emotion:

> Color, being an enigmatic thing in the sensations it gives us, can logically only be used enigmatically, every time it is employed, not for drawing but for giving the musical sensations which proceed out of its own nature, its own interior, mysterious, enigmatic force.[8]

The aesthetic of Gauguin, as of the other artists, is inadequately stated in his writings. In the few quotations cited above he has expressed his position on the important issues. In *Avant et après* he describes in a parable of some length his own technique; but nothing new to his aesthetic would be contributed by an exposition of it.[9]

The mysterious center of thought whose representation is possible only in symbol is a reinterpretation of the Schellingian Absolute. To Schelling nature and mind are the dual manifestations of an underlying reality. What this is we know only obscurely and we approach it best through aesthetic experience. Scientific explanations are superficial, for science describes only the symbol itself. Art is the highest form of human activity, for through it one experiences this deeper reality. To Gauguin the work of art and the feelings of the artist are both expressions of a common center. We know this center within us more clearly as it becomes objectified in a work of art. True

art is not a technical *tour de force* but a symbol of the
state of the artist's soul. So for Gauguin, too, art as a way
to reach the source of all experience is able to go beyond
science. Certainly the artist's theory echoes the romantic
poetry of Schelling's philosophy.

Elaborations on these aesthetic ideas suggested by
Gauguin were written by Maurice Denis, beginning with
a manifesto in 1890 entitled *Définition du néo-tradition-
nisme* and extending through more than thirty years of
critical writings of diminishing importance.[10] The name,
neo-traditionism, thus used to describe the movement, was
indicative of the religious interpretations which Denis put
upon symbolism, attempting, in looking back toward the
sacred art of the Renaissance, to make it a kind of glorified
Pre-Raphaelitism. The basic supposition upon which he
built his aesthetic, however, at least raised it above the
puerility of these earlier English painters. The much
quoted opening sentence of his manifesto is ample evidence
of this:

> It must be recalled that a picture—before it is a picture of battle-
> horse, nude woman, or some anecdote—is essentially a plane surface
> covered by colors arranged in a certain order.[11]

Denis opens his essay with this sentence as though it
were a truth we must recall and a self-evident proposition.
After all, a painting *as an object* is precisely a surface of
colors in orderly arrangement. This seems so obvious to us
today that we are apt to overlook the importance of such
a statement in 1890. To the public at that time this
remark was revolutionary. One still looked at a painting
as a picture of something, and to be told that subject
matter is only secondary demands a complete re-education
of one's artistic vision. Comparison of a painting with a
natural object is no longer the basis for an aesthetic judg-
ment, but the spectator must adjust his vision to the

intentions of the artist. The consequences of this astonishing statement were twofold. In the first place, the artist was no longer practically bound by a relationship between his picture and any natural object in respect to form and color. These qualities could become variable in the interests of expressive power. That such was the program of symbolism is undeniable; one need only look at Gauguin's painting to verify it. In the second place, theoretically a new basis of relationship had to be sought between the work of art and its model.

Denis tried to clarify this new relationship by seeking a re-definition of nature for painting. If we accept the current theory of art, he continues, that nature is the total of optic sensations, we have not given just place to the power of cerebral habits on vision. Does not Signac set out to prove that chromatic perception is necessary, and does not academic Bouguereau believe he copies nature? [12] By our own will we see nature in art, and the painter sees art in nature:

> You will see in each picture whatever you will have wished to see there. . . . And the converse is true. There is an ineluctable tendency among painters to carry back to the aspects of a picture already seen appearances perceived in reality.[13]

As a result of this practice modern artists have formed the habit of interpreting their sensations. Littérateurs call this habit temperament. When one says art is "nature seen through a temperament"[14] the definition is just because it is vague, but it leaves uncertain the important point, namely, what is the criterion of temperament. The definition covers the painting of those who strive for literary effects by failing to go beyond a superficial vision. Nature as surface qualities is *le trompe-l'oeil* of the crowd, the grapes of antique painting which the birds came down to peck, the battle scene of Detaille, where one doubts

whether the figures are real or on canvas.[15] Nature itself is
constantly changing. Our desires and cerebral habits made
the nature which is the subject of our sensations only an
occasion for artistic creation. Nature for the artist, as
Denis was definitely to state years later, is " a state of his
own subjectivity." [16] The parallelism in art is not to be
found between the work of art and the subject matter,
but between the work of art and the aesthetic emotions of
the painter. The meanness of *trompe-l'oeil* is a literary
effect.

The value of a work of art arises in the artist himself,
not in his subject: " From the state of soul of the artist
comes, unconsciously or almost so, all the feeling of a work
of art." [17] The artist himself brings into being the beauty
of the work of art. This beauty is the expressive form of
the work itself. It is the Byzantine Christ, which is a
symbol for the religious feeling of its maker, in contrast to
the modern copied, literary Christ. " In all periods of
decadence the plastic arts have shed their leaves in literary
affectations and naturalistic negations." [18] The expressive
quality of a work of art lies in the manner in which the
subject is presented, not in the subject itself. Before a
Calvary scene " our superior impression of the moral
order . . . could not arise from the represented motif or
motifs of nature, but from the representation itself, from
the forms and colorings." [19] The work of art is an arrange-
ment of colors which corresponds to the emotion of the
artist. It is a symbol:

> Art is the sanctification of nature, of the nature of the whole world
> which is content with living. What is great art, that which is called
> decorative, but the disguise of everyday sensations and natural
> objects, in sacred, hermetic, imposing icons.[20]

This conception of the correspondence between the emo-
tion of the artist and the plastic representation is the

distinguishing point between symbolism and other theories of art. It is a *felt* correspondence, is intuitive, existing between the whole work of art in its entirety and the feeling of the artist. The correspondence sought by the neo-impressionist was an objectively determined correspondence between a specific emotional reaction and the condition of a particular element in the work. The work of art is calculated to convince and is carefully laid out like an argument in syllogistic form. The symbolist work of art is an emotionalized burst, and the verity of its correspondence with the feeling of the artist finds its justification precisely in the feeling which determined its own embodiment. This notion of art as symbolic Denis set forth repeatedly.[21] It is also found in slightly modified form in Matisse's defense of fauvism.

Fauvism, like impressionism, is best described as a coincidence of taste among a group of artists for a more or less indefinite period of time. It received its impetus from the free use of color and the attraction for primitive art which symbolism introduced. The painters of the group first called themselves *les incoherénts* and were the principal representatives of the newly formed *Salon d'Automne* of 1903. In 1905 the name by which they were subsequently known was given them by the critic, Louis Vauxcelles, who described the gallery in which they exhibited in the autumn salon of that year as a *cage aux fauves*, deriding the wild quality of their color work. In three more years most of the group had moved on to other styles of painting. The spiritual leader of the group was Matisse. Theoretically their point of departure was the opening sentence of Denis' *Definition* of 1890, that a painting is a pattern of colors.

Matisse published the theory of fauvism in a lengthy article entitled *Notes d'un peintre* in 1908 [22] and supple-

mented his ideas in two short interviews in 1929.[23] The calm theoretical presentation of the 1908 article seems in no way analogous to his markedly rhythmical painting. But both show the Bergsonian anti-intellectualism that was so strong in the fields of practical action in the decade preceding the First World War.[24]

His heritage from Gauguin is immediately visible:

What I seek to get above everything else is expression. . . . I cannot distinguish between the feeling I have for life and the artistic technique with which I translate it. . . . The expression is the whole disposition of my picture. The place the volumes occupy, the space about them, the proportions, all have their part.[25]

The vehicle of expression in painting is the compositional arrangement of the picture. The painter concentrates his feelings by it. But certain feelings are fleeting, such as charm, lightness, and the momentary interpretations caught by the impressionists. If his subject is in motion, for instance, he must not isolate in thought the present moment from that which precedes or follows. He must be conscious of the entire action and endeavor to render its quality.[26] Expressive composition makes its own demands upon the artist:

It is not possible for me to copy nature servilely, because I am forced to interpret it and to subject it to the spirit of the picture. When I have found all my harmonies of tones there ought to result a complete accord of living colors, a harmony analogous to that of musical composition.[27]

Color has an important function in composition:

The dominant tendency of color is to serve expression as best it can. . . . The expressive side of colors is imposed on me in a purely instinctive way.

The choice of my colors does not repose on any scientific theory, it is based on observation, on sentiment, on my own sensibility.[28]

The instinctive quality of art is constantly emphasized through all this. The painter does not proceed by thought so much as by sensibility. Consequently he does not work by established rules. Rules belong to his own nature: " Rules have no existence outside of individuals." [29] His instinctive use of color as a compositional element may even lead the painter to distort the figures in his work. Natural appearances must always give way to compositional arrangements. The principle of distortion is of prime importance in expressionist aesthetics. Painters who proceed upon the imitation theory strive to depict objects as they are perceived. On the other hand, those painters who attempt to make art a vehicle for expressing their consciousness of life mold their subject as they translate it from natural space to the canvas until they are satisfied it embodies some meaning which any other form of rendition would not convey. They are not guided by perception but by " aesthetic intuition." For them a work of art has reference not only to the object which it represents but to a feeling on the part of the artist. As such it is a symbol. If one refers the work to the object then it falsifies that object. The principal reference of the work is to the meaning which the artist gave it, and the work does not falsify that meaning (insofar as the artist's technique was able to express it adequately) .[30] Intuition as contrasted to reason is opposed to discursive modes of thought. It seems more in harmony with the imaginative life of the child or the primitive. And so the expressionist painter finds inspiration in the distortions of primitive art. In fairness to Matisse it must be observed that however much his theory has seemed purely expressionistic, he does state that neither the imitative nor the intuitive principle should be preached to the exclusion of the other.[31]

Since the work of art is a symbol whose principal reference is to the feeling of the artist, the spectator must make the reference to the subject subordinate to this more important one. And this being a reference instinctively made, the ideal work of art would open its meaning to us without intellectual effort:

> When I see the frescoes of Giotto at Padua I am not concerned to know what scene from the life of Christ I have before me, but immediately I understand the feeling which it conveys for it is in the lines, the composition, the color, and the title only confirms my impression.
>
> What I dream of is an art of equilibrium, purity, and tranquillity, without disquieting or disturbing subjects, which could be for the mental worker, the business man, and the man of letters too, for example, a mental refreshment and relaxation, something analogous to a good easy chair in which one rests from his physical fatigue.[32]

The fauves cast the perceptual world into the background in favor of an intuited world. This intuition is a consciousness of life which is of the nature of a religious attitude. They make no distinction between their consciousness of life and their manner of expressing it. The work of art is thus a sample of the feeling it expresses. It is the only rendition of that feeling in concrete form. The work of art is therefore a symbol in a special sense. We usually think of a symbol as that which represents an object in virtue of an idea in the mind of the one using it, without which the connection would not exist.[33] That is, we say 3 is a symbol for the number three. But there is nothing in the shape of this figure itself which suggests three; by recognized convention the symbol has come to represent the number. This interpretation of the symbol will not hold when we come to the theory of the symbolic function of a work of art as presented above. Here a transformation has taken place by which the work of art is at the same time the objectified feelings of the artist. The

mind moves from the symbol to the symbolized of its own accord. There is no mediating ideational rule or convention.

Croce's aesthetic is similar. His philosophical problem being to examine human activity, he recognizes two such types of activity, knowledge and practice. Knowledge he further divides into two varieties, a pre-perceptual kind obtained through the intuition, and intellectual knowledge. The artistic activity is of the first, for it is concerned with the expression of our interior feelings. As a matter of fact intuition is precisely expression. Croce further agrees with symbolist and fauve theory in denying that beauty or ugliness inheres in certain forms or certain colors. We cannot weigh or measure these elements as embodying any aesthetic value in themselves, as the neo-impressionists had done. Denis and Matisse state that one finds the feelings of the artist expressed through the colors, the forms, or the composition, but they do not attribute that feeling as arising from any particular arrangement of elements. The artist's sensibility guides his arrangements and tells him when they give a satisfactory rendition of his emotions.

As noted in considering the aesthetic of Renoir, Bergson, too, was famous for making the appreciation of art intuitive. Aesthetically intuition is a sympathetic feeling for human emotional content in an object. It is the power *par excellence* of the artist.

In symbolist and fauve theory the value of art lies in its expression of human feelings. The painting is a symbol of the painter's psychic state. The spectator is immediately aware of this emotional content in the work. Denis says there is a correspondence between the arrangement of colors in a painting and the emotion of the artist. Matisse says that the composition of a painting must give a discharge of feeling. In both cases it would seem that

the value belongs to the formal elements themselves. The important thing is that whatever value the color or composition has it owes to the emotional content which the artist has put there. Yet the content is itself this color and composition. The painting is what it means and means what it is. Also it seems clear that this symbolic meaning which is the feeling of the artist can be experienced by the spectator. He simply responds aesthetically to the picture by tuning to the artist's emotional wave length, so to speak. Being painters and not aestheticians these men who have recorded their theories of art have stopped short of the crucial question which their theories bring up, or fail to see the tenuous and controversial positions into which they are led. Is the emotional reaction of a spectator before a painting the same as the artist's? Is there no place for individual reaction to works of art? If all spectators and the artist find an emotional coincidence before a work of art, then is not art a language, a thing of public experience? If this is so, then is not an attempt to make a calculus of that language or to explore it semantically, as the neo-impressionists tried to do, a justifiable and necessary labor? Or are we back to a mystical interpretation of art which says much but explains little, telling us finally that art is inexplicable? These painters fail to see their theory opens up numerous questions.[34]

When a painter establishes a correspondence between the work and his feelings, as these painters do, he is attributing to the object his own emotions and kinaesthetic sensations. In this respect symbolism and fauvism are empathy theories. In the last quarter of the nineteenth century and the first quarter of the present one Einfühlung occurred in various forms. As first used by Robert Vischer in 1873 the term *Einfühlung* was descriptive of the act by which one projects into the object before him his own

psychic feelings. He emphasizes or " feels-into " the object qualities which properly belong to himself. As such the word is a psychological, descriptive term for the childish, primitivistic, or artistic habit of animism. The aesthetic experience is explained by the various exponents of Ein- fühlung as a transfer of one's own kinaesthetic sensations, muscular adjustments, or emotional reactions from oneself to the work of art or natural scene. In the classical for- mulation of the doctrine made by Lipps a study is made of the relations of various formal elements such as design or color to particular emotions. As a result laws governing these formal elements of all aesthetic objects can be formu- lated. In this respect the neo-impressionist theory of Seurat in its definite statement of the relations between emotions and line, color, and shade is also an example of empathy theory. A critique of Einfühlung is not here in order. The theory merely supplies a name describing the habit of transferring one's emotions from subject to object, an attitude which is fundamental to symbolist and fauve theories of art. The belief that certain forms and colors have an expressive value in themselves does not belong exclusively to the painter of this time. The introduction of the " new " experimental psychology, begun with Fechner and continued particularly in Germany, had brought the techniques of the laboratory to bear on the problem of hedonics. From this work a psychological aesthetic has resulted, wherein a statistical definition of a pleasing object is attempted. Studies in the affective quality of various simple shapes and colors, and an aes- thetics based on experimental investigations are now important branches of psychological inquiry.

The projection of feeling into a work of art by artist and spectator also finds expression in formal aesthetics. George Santayana only a few years previously had explained the

perception of beauty as objectified pleasure, noting this transfer of quality to the object.[35]

The rise of religious sentiment in art was part of a definite current in French thought at the time. The renaissance of Catholic philosophy in Maurice Blondel, Péguy, Laberthonnière, and others at the turn of the century was as strong as traditionalism had been almost a century before. It was probably this new traditionalism that accounted for some of the symbolists moving in the direction of religious painting exclusively.

NOTES

[1] The Vogue for Japanese color prints was largely responsible for bringing about this change in style.

[2] Cf. R. H. Wilenski, *Modern French Painters*, pp. 98, 137, 142.

[3] For Gauguin's writings see bibliography. Those passages which bear on art and sum up his aesthetic have been collected by Jean de Rotonchamp, *Paul Gauguin* (Chapter X). Where possible references will be made to this book as the most convenient and practicable source since I have been unable to obtain the original sources in several instances.

[4] J. de Rotonchamp, *Paul Gauguin*, p. 152.

[5] *Ibid.*, p. 245.

[6] *Ibid.*, p. 243.

[7] *Ibid.*, pp. 246-247.

[8] *Ibid.*, p. 244.

[9] Gauguin, *Avant et après*, pp. 55-59; also in Rotonchamp, *op. cit.*, pp. 247-250.

[10] Maurice Denis, b. 1870, painter associated with the Nabis and the symbolist movement and an important theoretician. Journeys to Germany and Italy resulted in his being deeply influenced by the Nazarenes and the Italian primitives. His religious inclination is reflected in his preference for sacred art, and in his founding, in 1919 with Georges Desvallières the *Atelier d'Art Sacré*. His principal works are church and public building decorations. His critical essays have been collected in *Théories, 1890-1910*, and in *Nouvelles théories*, etc. (cf. bibliography).

[11] " Definition de néo-traditionnisme," first published in *Art et Critique*, August 23-30, 1890, reprinted in Maurice Denis *Théories, 1890-1910*, pp. 1-13, to which edition page references are here made. Quotations by the kind permission of Art Catholique. Above passage p. 1.

[12] *Ibid.*, p. 1.

[13] *Ibid.*, p. 2.

[14] The definition Émile Zola gave in *Mes Haines*, p. 24 in the Bernouard edition of his *Oeuvres Complètes*.

[15] *Théories*, pp. 2-9.

[16] " De Gauguin et de Van Gogh au classicism," 1909, *Théories*, p. 267.

[17] " Definition," *Théories*, p. 9.

[18] *Ibid.*, p. 8.

[19] *Ibid.*, p. 10.

[20] *Ibid.*, p. 12.

[21] *Vide* in *Théories*, pp. 41, 180, 259-260, 263.

[22] Published in the *Grande Revue*, December 25, 1908.

[23] E. Teriade, " Interview with Matisse," in *L'intransigeant*, Jan. 14 and 22, 1929.

[24] *Vide*, e. g., L. Quintanilla, *Bergsonisme et politique*, Ph. D. dissertation, The Johns Hopkins University, 1936.

[25] H. Matisse, " Notes d'un peintre," *Grande Revue*, Dec. 25, 1908, p. 733.

[26] Cf. *ibid.*, pp. 732-736.

[27] *Ibid.*, p. 739.

[28] *Ibid.*, pp. 739-740.

[29] *Ibid.*, p. 744.

[30] Cf. W. M. Urban, *Language and Reality*, pp. 423-426.

[31] Cf. Matisse, *op. cit.*, p. 742.

[32] *Ibid.*, pp. 741-742.

[33] Cf. C. S. Peirce, *Collected Papers*, vol. II, par. 299.

[34] Cf. L. Stein, *The A-B-C of Aesthetics*, especially chapters IX, X, XI.

[35] G. Santayana, *The Sense of Beauty*.

EARLY CUBISM

ANOTHER variant of realist aesthetics was possible, and that was to declare that the artist's business is to paint the real object but to reinterpret what is meant by a real object, denying that reality is in perceptual appearance but is a deeper essential quality in an object. This was the way of Cubism.

The same year that Matisse published his *Notes d'un peintre* he gave the name cubism to a new manner of painting in which his former confrère, Braque, had rendered a landscape. He shook his head with genuine concern and spoke of *les petits cubes*. Influenced by Negro sculpture and Cézanne's later work and encouraged by the latter's remarks about treating nature as cones, spheres and cylinders, the cubist movement had solidified by 1911 when the first exhibition was held at the *Salon des Indépendents*. Guillaume Apollinaire was the critical champion of the group.

The fortunes of cubism have been long and varied. Various stylistic changes have been duly noted and labeled.[1] Its influence has been far reaching. Constructivism, neo-plasticism, purism are variations on it.[2] It has given birth to sporadic schismatic movements like orphism.[3] From its inception it flourished more than twenty years.[4] The immediate impetus of the movement was in its early phase until the First World War and the present examination will be limited to this phase. A sufficient insight can be gained within this limitation.

An essay on the doctrines of cubism was published in 1912 by Albert Gleizes and Jean Metzinger under the title of *Du cubisme*. This small book represents the first

important manifesto issued by any of the artists of the movement.

Preceding the theoretical discussion is an important section on the history of painting since Courbet to set in relief the fundamental assumptions of cubism. Courbet, the authors say, accepted the retinal world without any intellectual control. His principal concern was to render the subject exactly as it appeared to him. But the world of the retinal image is a vitiated world, and a true realist would not be one who limited himself to it but takes it as already controlled by his artistic intent:

> The visible world does not become the real world except through the operation of thought, and . . . the objects which strike us with the most force are not always those whose existence is the richest in plastic truths.[5]

What this real world is unfolds as we move through the preliminary section. After Manet the realist tendency diverged. There was the new superficial realism of impressionism where the paintings were productions from purely retinal stimulations and in which forms atrophy and disappear. And there was the profound realism of Cézanne where painting is an art that gives plastic consciousness to instinct, where painting searches for reality.[6]

Objects have plastic truth when their volumes and dimensions can be satisfactorily rendered in the medium of painting. Plastic truth is the result of reason. Artistic space and the space of things in sensation are at most only analogous. This distinction between the real world and the visible world, presented as the difference between Cézanne on the one hand and the impressionists on the other, is fundamental to cubist doctrine.

Plastic truth is found only in anti-decorative art. Decorative art, that which exists as having its *raison d'être* outside of itself, " only becomes a living work in virtue of

the relations which are established between it and de-
terminate objects."[7] The relationship may be that be-
tween a picture and its surroundings. For instance a
Resurrection scene is appropriate to the church in which
one finds it. In anti-decorative art a " picture carries in
itself its reason for being."[8] It may be carried away from
church to drawing room, to gallery, and it always remains
complete, satisfying in itself. " It is in accord with every-
thing, the whole universe; it is an organism."[9] Or the rela-
tionship may be that between the pictorial world and the
visual world of the model. Both may be a decorative
pattern, or both may have deeper aspects:

> Oil painting today permits the expression of notions [heretofore]
> deemed inexpressible, those of depth, density, and duration, and it
> incites us to represent according to a complex rhythm and in a
> restricted space a veritable fusion of objects.[10]

Non-decorative art expresses the permanence of objects
in substantial physical form, and deals with extended
matter in its unchanging aspects: extension, density, dura-
tion. These are qualities of an object which are known by
analysis and by inference. It is such an object that pro-
found art strives to depict. A work of art of this profound
manner is in agreement with all other things of the uni-
verse. It has plastic truth.

This attempt to replace in painting the visible, retinal
world by a rational world which is declared to be more real
is a direct parallel in aesthetics to the critique of scientific
methodology made by Meyerson. The first edition of
Identité et réalité appeared in 1908, the same year that
Cubism began to attract attention, and the second was
issued in the same year as *Du cubisme*, 1912. Meyerson
distinguished positivistic legalism and causality. Legalism
can only give laws which must be accepted. A causal
explanation yields an equality whereby cause and effect

are identified. This demands that we must make mental simplifications and strive to get rid of sensory qualities, for sensory qualities change and we can get no identity with them. Scientific method must, and historically did, proceed by finding the permanence behind change. We say that we have explained something when observable effects are rationally equated with a cause. For example, the symptoms of a disease announce to the physician that in the body of the sick person there are, for instance, a number of particular germs above a given amount which have caused this illness. We say that the disease is the presence of these germs in the body, but it is also the abnormal condition of that body, the symptoms that are observable. The disease is identified with the effect and with the cause. An explanation is made when thought operates on observation.

Superficial realism, the cubist might say, yields only a legalistic artistic expression on the level of appearance; the new profound art of Cézanne and the cubists is a form of expression on the level of reality.

The second section of *Du cubisme* deals with what is called "the integration of plastic consciousness." This is a term which covers both artistic sensation and the procedures of artistry. Plastic consciousness "discerns a form" and then proceeds to render perceptible the relation between the world and the thought of the artist.[11]

> To discern a form implies, aside from the visual function and the faculty of being moved, a certain development of the spirit. The exterior world is amorphous to the eyes of the majority.
>
> To discern a form is to verify it by a preëxistent idea, an act which no one, unless he is a man we call an artist, does without exterior aid.[12]

The form is the permanent qualities of the world before us. Its recognition, not being an act of sensation, which

catches only the fleeting aspects, is a kind of mental aware-
ness. The word discernment seems a happy choice. It
suggests recognition and ideation. The artist's discern-
ment is superior to other men's because he has a capacity
of " spirit " which enables him to seize the forms of things
without immediate referenda. The child, it is said, must
compare his sensations to the picture-book; the man com-
pares his to works of art to coördinate them and render
them subject to mental control.[13] The child recognizes the
animal in the zoo from his picture-book drawings. The
grown person sees the Grand Canal through Guardi and
Turner and Westminster Bridge through Monet. The
artist sees the world directly and without external aid.

The artist, having discerned a form, prefers that form insofar as it
presents a certain intensity of analogy to his preëxistent idea and
consequently—for we impose our own preferences on others—he exerts
himself to enclose the quality of that form (the immeasurable sum of
affinities glimpsed between the visible manifestation and the tendency
of his spirit) in a sign proper to affect others. . . . The painter, care-
ful to create, rejects the natural image as soon as it has served his
purpose.[14]

The artist must reject the natural image because a work
of art which has an application to two categories, the
natural and the artistic, is a confused result.[15] We ought
not judge art by similarity to nature. A landscape scene in
art, for example, should be something of entirely different
spatial relations from that landscape in nature. The di-
mensions of art are not those of observation. If the dimen-
sions and proportions of the natural scene are relatively
intact in a painting, the genius of the painter is not thereby
exhibited. The picture is not aesthetically effective. The
mission of the artist is not to imitate but to translate.
Yet " the reminiscence of natural forms could not be abso-
lutely banished. . . . the cubist painters know this." [16]

The abstraction is not complete. The object as translated by art is still a " reminiscence " of the natural object. The difference between visual space and pictorial space dictates the difference between the natural image and the artistic rendition.

Visual space depends upon the " sensation of convergence." In art this convergence is represented by perspective. But pictorial space need not depend upon perspective. Infractions of the rules of perspective do not compromise spatiality. In Chinese painting there is space without perspective.[17]

In order to establish pictorial space it is necessary to have recourse to tactile [18] and motor sensations and to all our faculties. Our whole personality, contracting or expanding, transforms the plane of the picture. When this plane in reaction is reflected on the understanding of the spectator pictorial space is defined: a sensible passage between two subjective spaces.[19]

Pictorial space is the space which embodies discerned forms, tactual, motor, and ideational, besides purely visual ones. It is the context in which these forms are rendered for the perception of others.

Ideational forms and visual shapes are in constant interplay. An ellipse may become a circle when inscribed in a polygon. One emphatic form may govern a picture; one leaf of a tree may be imitated and thereby the whole tree seem to be represented. " The eye quickly makes the mind interested in its ways." [20] The mind continually plays with the nuances of shape. " Composing, constructing, designing all come back to this: regulating through our own activity the dynamism of form." [21] Shapes are only " nuances of the notion of plenitude," [22] which plenitude is form. In the design of a picture there is a relationship between straight lines and curves. A work of art moves us when it embodies this relationship as an indefinite diver-

sity (not all straight lines or curves, or an equal balance between them).[23] Exterior shapes are constantly being modified by one another but our mind sees the permanent form beneath them.

The artist tries to symbolize the quality of this form. He does this by catching the weight, density, and bulk, the visual, kinaesthetic, and intellectual aspects of his model. In this manner he makes the work of art an organism in which all qualities are coalesced in a kind of vital conjunction.

Nuances of form and nuances of color also affect each other:

> All inflection of form is heightened by a modification of color; all modification of color engenders a form.[24]

Ideational and sensory content constantly interplay. This rational interplay is the only reality:

> There is nothing real outside us; there is nothing real but the coincidence of a sensation and an individual mental direction. It is not our intention to cast in doubt the existence of objects which affect our senses; but there is reasonable certitude only in regard to the image which these call forth in our minds.[25]

Since forms are ideational there is no single one belonging to each object:

> An object hasn't just one absolute form; it has many. It has as many as there are planes in the domain of signification.[26]
>
> There are as many images of an object as there are eyes to see it; there are as many essential images of an object as there are minds to understand it.[27]

The object the painter knows is different from the object the scientist knows; the object as seen from one position is not the object as seen from another. No one of these aspects alone is the object; it is the fusion of all these

mental appearances. This is the complete object that the cubist tries to crowd into pictorial space:

> We are sure that the least sagacious will soon acknowledge that the pretention of making the weight of a body apparent and the time spent in numbering its diverse aspects is as legitimate as that of imitating the daylight by the shock of a blue and an orange. Then the fact that an object is moved about in order to have its many successive appearances caught, when these appearances blend into a single image and reconstitute the object in duration, will no longer rouse the indignation of reasonable people.[28]

We are warned, though, that this desire to get down in pictorial form such an aggregate object must not be taken too literally. The artist should not painfully juxtapose the six faces of a cube or the two ears of a model seen in profile.[29]

This notion of a conceptual object as a system of appearances also occurs in formal philosophical work at about the same time. Bertrand Russell, for example, under the admitted influence of A. N. Whitehead began to treat " things and the whole conception of the world of physics as a *construction* rather than an *inference*." [30] The appearance of objects changes with the " point of view " of the observer. The perspective, that is appearance, of one observer is not that of another observer. Unperceived perspectives are also conceivable. The object itself is not the cause of these appearances but is the whole system of them. " Given an object in one perspective, form the system of all the objects correlated with it in all the perspectives;" [31] (this sounds like a program for cubist painting). When the time element is considered the object becomes an event spread out in space-time. If it is located at any place it is located at the point of intersection of all its appearances. But that is the only place at which no perspective is possible, so that the object is everywhere but in the position we attribute to it. We must go all

around it to find it. It is a " logical construction " of this system of aspects. A cubist picture is the pictorial image of such an object.

The parallel between cubist theory and new realist philosophy is surprising at first, but undeniable. Whether the relationship was accidental coincidence or one in which there are traceable connections is a question that conjecture will not settle.

Gleizes and Metzinger's theory of cubism makes painting a rationalized enterprize. The business of the artist is no longer to reproduce the surface appearance of natural objects, or the world as he emotionally experiences it. The object he paints is a logical formalization of the natural model. Things in the natural world are measured by their correspondence to an idea. The categories of painting and the natural world are separate, but the painter still tries to move from one to the other. He has not yet given up his model completely. He views the world through the mind and molds it to his view.

NOTES

[1] Cf. the distinction between analytic and synthetic cubism made by A. H. Barr, Jr., *Cubism and Abstract Art*; the fourfold distinction made by Apollinaire, *Les peintres cubistes*, and the classification of Wilenski, *The Modern Movement in Art*.

[2] Constructivism: Russian art movement, 1913-1922 being the years of its greatest activity, which constructed from glass, wood, plaster, metal, etc. models of abstract design.

Neo-Plasticism: style of painting of the Dutch artist, Piet Mondrian, in which the canvas is divided into rectangles of color and greys by thick black lines, cf. manifesto of Modrian, *Le néo-plasticisme*, 1920.

Purism: French theory of painting which flourished in the decade following the war reacting against what it considered decorative tendencies in cubism and drawing its inspiration from the efficient and functional appearance of machines. Cf. Ozenfant and Jeanneret, *Après le cubisme* and *La peinture Moderne*.

[3] Orphism: manner of painting employed about 1912 by Robert Delaunay and Frank Kupka, consisting in the use of abstract color designs for their own sake. It was influential in bringing subsequent cubism to a freer use of color than it had previously employed. Cf. letter of Robert Delaunay in G. Coquiot, *Les indépendants, 1884-1920*, pp. 181-182, " everything is color and movement."

[4] For above information concerning cubism and related movements cf. A. H. Barr, Jr., *Cubism and Abstract Art.*

[5] Gleizes and Metzinger, *Du cubisme*, p. 6.

[6] *Ibid.*, pp. 8-10.

[7] *Ibid.*, p. 11.

[8] *Loc. cit.*

[9] *Ibid.*, p. 12.

[10] *Loc. cit.*

[11] *Ibid.*, pp. 13-15.

[12] *Ibid.*, p. 13.

[13] *Loc. cit.* Does not, for example, a European's picture of a landscape seem queer to a Chinese who has become accustomed to seeing landscape through his native art?

[14] *Ibid.*, pp. 13-14.

[15] *Ibid.*, pp. 14-15.

[16] *Ibid.*, p. 17.

[17] *Ibid.*, p. 18.

[18] The importance of tactile sensations in painting had been emphasized just prior to this time by Berenson in his *Florentine Painters of the Renaissance.*

[19] Gleizes and Metzinger, *op. cit.*, p. 18.

[20] *Ibid.*, p. 19.

[21] *Loc. cit.*

[22] *Ibid.*, p. 20.

[23] *Ibid.*, pp. 20-21.

[24] *Ibid.*, p. 29.

[25] *Ibid.*, p. 30.

[26] *Ibid.*, pp. 30-31.

[27] *Ibid.*, p. 32.

[28] *Ibid.*, p. 36.

[29] Picasso, however, does a similar thing in his later cubist work, showing two eyes in a profile face in his *Seated Woman* in 1927.

[30] B. Russell, *Our Knowledge of the External World*, 1914, p. vi.

[31] *Ibid.*, p. 89, Lecture III, pp. 63-97.

SURREALISM

THE FINAL phase of this history is the consideration of an aesthetic which denies all the theses of realism and expands upon the symbolist and expressionist doctrines until they are scarcely recognizable. Surrealism has led an uninhibited and boisterous existence among us for nearly twenty-five years. As the exploration of a particular point of view which is in revolt against the accepted standards of art and criticism it has faced the snobbism of aesthetician and critic. Since it has come of age as a taste whose influence bids fair to become as far-reaching as its antecedents are numerous, whose rise and importance in interwar culture is interesting and astonishing, it demands sympathetic study.

Though not born until eight years later surrealism was conceived in 1916. It received its name from its literary godfather, Guillaume Apollinaire, who designated as *surréaliste* a drama which he wrote in that year entitled *Les mammelles de Tirésias*. The word was later adopted by André Breton to describe the attitude of dream thought and psychic automatism that was engaging his attention. Its mother was dada, from whose body it was born.

Dada made its debut during the First World War in 1916 at the Cabaret Voltaire in Zurich, and its nihilistic attitude quickly spread among the disillusioned artists of Europe. It was so named, as one story goes, because *dada* was the first word which met the eye of Tristan Tzara when he inserted a paperknife in a dictionary at random and opened the book to that place. If its adherents ever had any illusions about art they abandoned them in dada, for dada was the display of nonsense for its own sake.

Manifestoes were read by the score to damn art and thought and manifestoes and dada itself:

> I write a manifesto and I don't want anything. Yet I say certain things, and I am by principle against manifestoes as I am also against principles. . . . I write this manifesto to show that one can take opposite actions at the same time in one cool breath. I am against action, in favor of continual contradiction and for affirmation also. I am neither for nor against and I do not explain for I hate good sense.[1]

Such was the turn of mind out of which surrealism came.

Surrealism was formulated and given a program by André Breton, one of the Paris dadaists. A medical student as well as a poet, he proposed to investigate the possibilities offered by literary activity freed from rational control as a method of psychoanalysis. In his *Manifeste du surréalisme* of 1924, he first attempts a definition, describes it, and indicates its background. Though not the work of a painter this manifesto must be considered to understand the point of view of surrealism, which is more than a theory of art.

Breton first describes the turn of thought distinctive of surrealism in contrast to the conventional, realist attitude. This attitude refers to an absolute rationalism which has the fixed limits of discursive reason, is always in agreement with common sense, and confines itself to the tautological possibilities of logic:

> We still live under the reign of logic. . . . But nowadays logical processes are applied only to resolving problems of secondary interest. [True] logical ends escape us, however. . . . Under color of civilization, under pretext of progress all that rightly or wrongly can be charged to superstition or fancy has been banned from the mind, all manner of searching for truth which does not conform to usage has been proscribed.[2]

On the other hand is the materialist attitude (for so he

calls it) which opens up the domain of the imagination and shows the true psychic life hidden beneath rationalization:

> The imagination is perhaps on the point of acquiring its rights. If the depths of our souls conceal strange forces capable of augmenting those on the surface or of struggling victoriously against them it is to our best interests to exploit them. . . .[3]

The imagination is identified with a subconsciousness that is made apparent to us through dreams. Breton acknowledges the debt of the surrealist to Freud. By affirming the unconscious surrealism begins to move away from dada and pure negation, to erect a positive structure. Accepting the authority of Freud that the subconscious is most easily apprehended in the dream state which " is continuous and carries trace of organization " whereas the waking state is only " a phenomenon of interference "[4] obeying unconscious suggestions, the surrealist examines this dream state with a new intent:

> I believe in the future resolution of these two states which in appearance are so contradictory, that of the dream and that of reality, into a kind of absolute reality, a *surreality*, if one may call it such.[5]

By dialectic the two contradictory states, the dream and reality, are absorbed by a deeper realm. This is the philosophic position of surrealism. The things of the outer world, though real in the sense that they have their own independent existence, lose this reality in our thought and enter into new relationships which are psychical, not physical. To the surrealist " a tomato is also a child's balloon " and in this relationship the word *like* is " suppressed."[6] Certainly in such a program our suspicions of the marvelous are put in disrepute and reason is *surclassé*.

We ask at this point, perhaps, for a description of this surreality. But this shows we misunderstand. The surreal is the last dark continent of the mind; it exists but we

cannot yet describe it for it has never been explored and its borders have barely been touched at times. It is here surrealist artistic techniques enter, for they are the methods by which the poet and the painter can explore the unconscious as does the psychologist. Surrealism, the philosophic position, posits the surreal; surrealism, the method, helps to describe it. The duality is apparent in Breton's definitions:

> SURREALISM, N. m. Pure psychic automatism by which it is proposed to express, either verbally, in writing, or by any other means, the real functioning of thought. A dictation of thinking, in the absence of all control exercised by reason and outside of all aesthetic or moral preoccupations.

> ENCYCL. Philos. Surrealism rests on the belief in the superior reality of certain forms of association neglected before its time, in the omnipotence of dreams, in the distinterested play of thought. It tends to ruin the definitiveness of all the other psychic mechanisms and to substitute itself for them in resolving the principal problems of life.[7]

Breton describes the first surrealist method whereby our activity is freed from rational control, psychic automatism. This is the attempt to record the stream of uninhibited verbal imagery for oneself as a psychoanalyst would that of a patient. In as passive a state as possible one writes down rapidly his flow of thought. Or one may draw at random in a kind of doodling.

The first manifesto clarifies the ideological basis of surrealism and describes one possible method for it.

In the *Second manifeste du surréalisme* of 1930, Breton declares that it is the purpose of surrealism to provoke a " crisis of consciousness " by exposing the falseness of the old antinomies which have so long prevented mankind from finding the common point of reference.[8] The exposure can best be made through a study of the problem of human expression for:

No one, in expressing himself, does better than to adjust himself to the possibility of the very obscure reconciliation of what he knew he had to say on a subject with that he didn't know he had to say but has said.[9]

The two most valuable means of expression are dream accounts and automatic texts (whether written, painted, or drawn makes no difference as their automaticity is evident in any one). They are valuable because they are the means to which one may turn when the object of artistic activity is not the production of works of art but the revealing of the psychic life. In artistic inspiration there occurs a kind of short circuit between an idea and its response.[10] For that reason art is valuable to the surrealist.

This gives rise to the all important question which brings us to the heart of the surrealist position. If we do have such an unconscious self as described why should we want to know about it and exercise it? The answer is found in the significance which is attached to the surreal. Down in this inner psychic life of each one of us we come to the human crucible itself, the overindividual state wherein exist the universal truth, beauty, and reality that all of us can comprehend. Here is not only the man himself but mankind. Here is the foundation upon which we must build our morals, our art and ways of thought, our life and actions:

The products of psychic activity . . . offer a key capable of opening indefinitely that box of multiple depths called man.[11]

In *Le surréalisme et la peinture* Breton presents the purposes and problems of surrealist activity in the plastic arts. Because mankind has felt the need of fixing his visual images, a plastic language has grown up corresponding to the various degrees of his sensations, the things we all see

and remember whether we will to or not, the things we do not dare see, that we see differently, that we cannot see. This plastic language is a reality as powerful in itself as the physical world, for when one turns to a picture the world that surrounds him is no more.[12] It is as easy to put the natural world in question as it is the world of art.

The attitude of the realist, who takes his model from the natural world, is the artistic equivalent of the discursive thinking of the realist in philosophy which the surrealist hates:

A very strict conception of *imitation,* which has been given as the purpose of art, is the root of a grave misunderstanding which we see persisting even until our time. On the belief that one is capable of reproducing with more or less success only the image of that which affects the sensations, painters have shown far too much timidity in the choice of their models. The error they made was in thinking the model could only be drawn from the exterior world, or even in thinking one could be taken. True, human sensibility can confer on the most common subject quite an unforseen distinction; but it is no less true that to make the magic power of figuration which some so happily possesses an aid to the conservation and reënforcement of what would exist without them is to make a beggarly use of that power. That is an inexcusable abdication. At all events it is impossible in our present state of thought, above all when the exterior world appears to be of a nature more and more suspect, to consent still to such a sacrifice. The plastic work, in order to respond to the necessity for the absolute revision of real values which all minds today agree is necessary, will refer to a purely interior model or will no longer exist.[13]

For the natural model surrealism substitutes the interior model, the mental world. The expression of this model reduces itself to the employment of iconographical devices which are personal to each painter. But do these various personal pictorial means have any public significance? Will the fragments from my subconscious speak to your subconscious simply because those portions of our minds both harbor similar repressions and erotic urges?

The aim of the surrealist is a complete reversal of critical values. In casting aside the artist's preoccupation with the rendering of natural objects, he makes such a complete rejection of this practice that he not only condemns realistic reproductions but also rejects any aesthetic based on the manipulation and expressive value of formal relationships. The surrealist work of art is a vehicle by which artist and spectator are brought up against the center of the world where thought and things meet. The work is a plastic sign of the surreal center and a fragment of it as well. The beauty of surrealist art is a convulsive beauty that creates " a physical disturbance in a spectator like a cutting wind on his face on a chilly day." [14]

Louis Aragon, the poet, in talking about collage art, had said that it was a method more akin to magical operations than to painting. The collage piece, which is an object in its own right, is put into a larger context which contains other pieces that are unrelated to the first and to one another. The result is that the pieces are transformed by the chance association. An electric bulb by itself is an electric bulb, but when put in a picture it has entered into a new context and may become for the artist a young girl.[15] The surrealist sees a new significance. Max Ernst, the German painter, defines it as " the miracle of the total transfiguration of any object either with or without modification of its physical or anatomical appearance." [16] Two mutually distinct realities coalesce by meeting through chance in a subconscious plane.[17] The collage is an excellent example of surrealism's non-aesthetic values in painting.

For Salvador Dali the whole ambition of the artist is to " materialize the images of concrete irrationality." He must record the interior model as faithfully and as clearly as any realist would copy his exterior model. If the artist

does not understand his pictures as he paints them it is because " their meaning is so profound . . . that it escapes the most simple analysis of logical intuition." [18]

The shift of values and overindividual content of the surreal Dali well expresses:

> The subconscious has a symbolic language that is truly a universal language, for it . . . speaks with the vocabulary of the great vital constants, sexual instinct, feeling of death, physical notion of the enigma of space—these vital constants are universally echoed in every human. To understand an *aesthetic* picture, training in appreciation is necessary, cultural and intellectual preparation. For surrealism the only requisite is a receptive and intuitive human being. [19]

The mysteries before which man is dumb, the questions which he voices and hazards answers to, are those of himself. The marvelous is within him and speaks to him through the vital constants.

Dali adds another kind of surrealist activity to those already mentioned, " paranoiac-critical activity." The images of reality are susceptible of false interpretations in terms of some mental delusion. The paranoiac does not deny that the object which others believe to be his hat is his hat to *them*; but he does deny it is such to *him*. For him it is an object which has entirely different relations to his mind because of the shifted viewpoint under which he sees it. For him it is really something else. Similarly, a picture of a horse may be seen as that of a woman also, or even further as a lion. Which of these it may be and how many images an individual may see depend upon his degree of paranoiac capacity. The images of reality depend upon this capacity as well, for reality may be as easily dissociated and put in question as illusion. [20] As Breton has said, one may look at a tomato and see a child's balloon. Knowledge for one who does this is not knowledge of things as they are in the world, but knowledge of

things as viewed through one's individual desires. The world of such a one is ego-centered, and however much anyone may claim the objective and subjective are telescoped, it is the subjective element which is in the ascendency. The rational is brought into line with the irrational, the world of common sense with that of illusion. When a work of art is a paranoiac phenomenon it is no longer an aesthetic object but is purely a psychiatrical index of one's unconscious activity.

This turbulent refusal of the mind to accept the given, ever substituting its own interpretations, has been called by Gaston Bachelard surrationalism. This term indicates the whole general state of mind in which the mind is supposedly liberated from the restrictions of logic by its own caprice. Surrationalism traces its origin to Lobatchewsky's discovery of a non-Euclidean geometry. For centuries a hardened rationalism had repeated the axioms and postulates of Euclidean geometry, without seeing that they may be freely rejected as they were freely accepted. Lobatchewsky dialecticized geometry and in so doing cast doubt on all fundamental issues, challenging the human mind to rise above them and free itself by its own imprudence.[21]

Such are the ideas of surrealism, the climax of twentieth-century anti-intellectualism. Its sources in fantastic art and erotic literature have been often pointed out. One could also mention the great wealth of fancy and imagery one meets in English literature, in never-never land, the looking-glass country, midsummernight dells, in the wealth of children's literature of which French literature is almost entirely devoid. But these are antecedents of the fanciful only.

The theoretical backgrounds of surrealism are found in the principle of dialectic which it inherited indirectly from Hegel, and in psychoanalytic method which it drew directly from Freud.

But surrealism's dialectic is more a word than a dialectic. It is not the dialectic of Hegel for reality and rationality do not logically generate their antithesis. There is no necessary movement from a given thesis to its opposite, and given both of them there seems no reason for supposing that there is possible any synthesis between them. The synthesis is one in name only; it is only a new label for reality. Though the rational and irrational, the mental and material are identified in surreality, all supposedly *aufgehoben* by the magic of a name, all that we can find there are the irrational, the marvelous, the illogical, the unreal. Though the whole theoretical polemic of surrealism debunks the intelligence and discursive reason, it fails to distinguish on the other hand between surreality and the irrational. If the surreal were a truly dialectical synthesis it would not be coextensive with the antithesis from which it proceeded. Liquidating the rational is not dialecticizing it. Furthermore, the surreal is always something which is assumed to inhere in mental life and consequently cannot be the bridge between the mental and actual worlds.

Surrationalism is not dialecticizing for it is nothing more than a misinterpretation of a very rational process. What is called dialecticizing geometry is the creation of systems of geometry which are mutually contradictory, by denying in one system a postulate affirmed in another. When Lobatchewskian geometry was thus " dialecticized " from Euclidean, the latter system was not thereby ruined, and from the two systems no synthesis results. There simply remain two different geometries, corresponding proposition for proposition. And when a third is established, all three exist side by side. Thought is not necessarily in any turbulent agression.

In examining surrealist activity the theoretical background is found entirely in psychological theory, for the

activities are altogether psychical and mainly subconscious. These activities may eventuate in material objects, pictures, poems, and the like, but the existence of these as material objects is always disregarded by the surrealists. They are looked upon simply as signs of the mental life being explored.

The immediate psychological background is Freud and Breton admits his indebtedness to him. The Viennese physician had specifically stated that the basis of our psychic life is the unconscious. The unconscious is no less real for not always being present. We know the unconscious through the conscious just as we know the external world through the senses, but in both cases the data supplied by our means of knowledge are insufficient to disclose the full nature of their reality.[22] Psychoanalytic theory presents the idea which surrealism interprets dialectically, that the unconscious includes the conscious. It is only a short step to the conception of the unconscious surreal as the container of the real state as well as the dream state in which it is more directly revealed. This is especially true since psychoanalysis is based upon a belief in an antagonism between the conscious and the unconscious parts of the mind, the former repressing those desires of the libido which are socially or morally reprehensible, but which, nevertheless, escape from the unconscious through sublimation. Surrealist poetry, painting, and objects frequently express either directly or symbolically their sexual associations. Surrealist freedom in artistic expression is the removal of the censorship which prevents the psychic unconscious from rising into consciousness. Breton's recipes for the production of automatic texts correspond in purpose to the analyst's desire to reject conscious directing ideas so that unconscious ones may determine our flow of thought.[23]

Freud was also important to the surrealists for suggesting to them a theme which they further capitalized, that ordinary life in its errors and dreams is not so very different, other than in degree, from the symptoms which one meets in psychosis and neurosis.[24] The relation of surrealism to madness is discussed by Breton,[35] and the introduction and acceptance of the paranoiac-critical method is based on the supposition that paranoia is prevalent in everyone to some extent at least.

Finally, the general correlation which Freud makes between these symptoms in civilized life and in pagan and primitive practices [26] might suggest the supposition of the surrealists that the unconscious surreal is not only the true " psyche " of the individual but is a center common to all men.

This theory of the surreal as the superindividual, however, is more closely akin to that of the " collective unconscious " put forth by C. G. Jung and the Zurich school of psychoanalysis, a schism from the original movement. The important characteristic of the unconscious for Jung is that it contains the heritage of all races:

> [Men] love their unconscious, that is, that remnant of ancient humanity and the centuries-old past in all people, namely, the common property left behind from all development. . . . But in loving this inheritance they love that which is common to all. Thus they turn back to the mother of humanity, that is to say, to the spirit of the race, and regain in this way something of that connection and of that mysterious and irresistable power which is imparted by the feeling of belonging to the herd.[27]

The surrealist distinction between rational thought and irrational activity is found exactly in Dr. Jung's distinction between " directed thinking " and " phantasy thinking." The first of these forms of thinking is logical thinking in which the images in our mind flow in a causal sequence

corresponding to exterior historical events. This type of
thinking is directed to the outside world. Its peculiarity is
that it tires one and hence can take place only for short
periods of time. Its material is language. In the second
kind of thinking the thoughts are not directed but rise and
fall by their own weight in a stream of associations. This
thinking does not tire us. In it images crowd upon images
and we leave the world of the present for the past, the
future, the would-be world of dreams. The source from
which phantasies draw their materials is the same as that
from which myth and folk-belief arose. The dream phan-
tasy is the last remnant of archaic thought, like a vestigial
organ of our physical evolution. It is for this reason that
phantasy thinking brings us back to the common mankind
of the past. The products of dream thought are day
dreams, the dreams of sleep, and the phantasies of those
with dissociated personalities.[28] The surrealist activity of
psychic automatism gives us the products of dreams; the
paranoiac-critical method is employed by those who have
a dissociated personality and can see woman, horse, and
lion in the same object. The surrealist theory of the de-
pendence of the rational upon an irrational foundation is
the parallel of Jung's contention that directed thinking is
connected with the very foundations of the human mind
through phantasy thinking. Phantasy thinking, which is
so largely unconscious (and Freud, remember, had in-
cluded consciousness in the unconscious) is the surrealist
activity which brings us down to the surreality, the collec-
tive unconscious. The surrealist believes that in eliminat-
ing from his thought and his art all rational controls or
moral and aesthetic preoccupations he is eliminating those
elements which hide what is common to all as a race.
Intellectualism is an added structure to the common
minimum of subconscious life. By stripping it away we

get down to the surreality where the vital constants wallow. The value of an exquisite corpse[29] is its importance as tangible evidence of the possibility that several persons together may explore the world of the irrational. By reducing the unconscious to the overindividual both Jung and the surrealists believe they are escaping the predicament of the mental giving us only a private world.

Now when the surrealist says that unless one can see the tomato as a balloon he is a cretin, or that one's paranoiac capacity accounts for the number of multiple images he may find in a picture, he has not removed the balloon or the image from the private world of the spectator, and he has just as much, on the other hand, left the tomato and picture as public property. The tomato has become a balloon for the individual who sees it as such, and that individual is not concerned whether the object is a tomato or a balloon to anyone else. It is a balloon in his imagination. The rational world is denied as far as he is concerned, and his own mental constructions are put in its place. The surrealist artist may conceive of his tomato as a balloon; a spectator may conceive the tomato· as something very different. Each is within his own imaginative world and the two are independent of each other. If the unconscious were the source of what is common to mankind, and if surrealist activity explores that unconscious, it is difficult to understand how so individual an activity as that by which a tomato becomes a balloon to one who looks at it can open up to him the overindividual depth of his nature. If a spectator ever feels any kinship with others before a work of art it is insofar as he can rationally interpret that work. Dadi's *Persistance of Memory*, for example, is capable of such interpretation. The lifeless watches devoured by ants and the scene without horizon depict memory as the death of time. If a work were not open to such in-

terpretation it would be hard to find in it any point of contact open to all minds.

Surrealist activity recognizes only the free play of the imagination. In this the artist becomes a passive instrument. This notion, too, of course, is not new with them. Plato noted the passivity of the artist in his *Ion* where he speaks of the poet as the inspired instrument of the gods, mysteriously directed by them in his work. In nineteenth-century France Delacroix voiced the belief in the artist as the servant of his art which inspires him and uses him for her own purpose.

An anti-rationalism which exalts the imagination is also not new in philosophy. Coleridge's distinction between fancy and the imagination is said to have corresponded to and proceeded from Hartley's descriptions of the difference between delirium and madness.[30] Fichte's belief that the imagination is the finite power which corresponds to the creative act of the Absolute makes the world a product of voluntaristic action. Among the other German romantics there is some similarity to surrealism's conception of imagination. For Novalis the philosopher becomes identified with the poet, and the source of poetic inspiration is the life of dreams. In Schelling one finds the combination of romantic idealism and dialectical struggle in nature which occurs in surrealism.

The aesthetician and the art critic, to say nothing of the moralist and the philosopher, are presented with a problem by this strange and heterogeneous theory which comes into their field with its destructive doctrine and perplexing works of art. They may scoff at it and deny its entrance into their world, turning it over to the psychiatrist as a case of mental abnormality, or they may accept its artistic activity, its works of art, and its theory as phenomena to be absorbed within a more general aesthetic.

It seems that the important place which surrealism has occupied in the world for the last two decades and the influence which it has had on traditional forms of art and on many artists who do not accept its principles, justify its consideration at least as a special case within a general theory of aesthetics and philosophy of art. It is the business of the aesthetician to systematize or explain as far as he can the material which is presented to him by artistic activity and not to prejudge this material on principles drawn up prior to the intrusion of the new material. Wild data must be admitted in aesthetics as much as in epistemology. If it does nothing else for the aesthetician surrealism should make him look to the grounds of his science.

Surrealism has gone back to a pre-positivistic romanticism for its theory and to a psychiatric theory which reverts to a new mythology to explain the human mind. With it our study has come full circle to the denial of the naïveté of realism by the substitution of a new fiction.

NOTES

[1] From " Manifeste dada 1918 " by Tristan Tzara, in Tzara, *Sept manifestes dada.* p. 18.

[2] A. Breton, *Manifeste du surréalisme*, p. 21.

[3] *Ibid.*, pp. 21-22.

[4] *Ibid.*, pp. 24-26.

[5] *Ibid.*, pp. 27-28.

[6] A. Breton, " Exhibition X . . Y . . . ," *What is Surrealism?* tr. D. Gascoyne, p. 25.

[7] A. Breton, *Manifeste*, p. 46.

[8] A. Breton, *Second Manifeste du surréalisme*, pp. 9-10.

[9] *Ibid.*, pp. 51-52.

[10] *Ibid.*, pp. 54-55.

[11] *Loc. cit.*

[12] A. Breton, *Le surréalisme et la peinture*, pp. 10-11.

[13] *Ibid.*, pp. 12-13.

[14] A. Breton, " Beauty Will be Convulsive." *What is Surrealism?* p. 37.

[15] L. Aragon, *La peinture au défi.* Collage is the method of constructing a picture by pasting pieces of various materials, glass, paper, wood, etc., on a background.

[16] *Dictionnaire abrégé du surréalisme,* p. 7.

[17] M. Ernst, " Inspiration to Order," *This Quarter,* Sept., 1932, pp. 79-80.

[18] S. Dali, *The Conquest of the Irrational,* pp. 12-13.

[19] S. Dali, Address delivered at M. M. A., 1934, from J. Levy, *Surrealism,* p. 7.

[20] S. Dali, *The conquest of the Irrational,* pp. 17-18; also *vide* " The Stinking Ass," *This Quarter,* Sept., 1932, pp. 49-51. Paranoia is a chronic form of mental disease in which the sufferer experiences delusions of persecution or grandeur. He interprets falsely the attitude of others toward him or accounts for the outer world in terms of his delusions. His delusion is a systematic, rational explanation, but is formed from false convictions or beliefs.

[21] Cf. G. Bachelard, " Surrationalism," in J. Levy, *Surrealism,* pp. 186-189.

[22] Cf. S. Freud, *The Interpretation of Dreams,* tr. A. A. Brill in *The Basic Writings of Sigmund Freud,* p. 542.

[23] Cf. *ibid.,* p. 482.

[24] Cf. S. Freud, *Psychopathology in Everyday Life,* in *op. cit.*

[25] A. Breton, " Surrealism and Madness," *This Quarter,* Sept., 1932. However, it is interesting to note that drawings by surrealists and those by the insane are quite different, the former retaining a trace of conventionality, artistically speaking, the latter being more infantile. Cf. H. Prinzhorn, *Bildnerei der Geisteskranken.*

[26] S. Freud, *Totem and Taboo,* in *op. cit.*

[27] Reprinted by permission of Dodd, Mead and Co., Inc. from C. G. Jung, *Psychology of the Unconscious,* tr. by B. Hinkle, pp. 200-201.

[28] *Ibid.,* pp. 12-21 and 32-37.

[29] Exquisite corpse, a composite picture drawn by several people one after the other, each one continuing where the former one has left off but with the previous part of the picture concealed from him. Hence the irrationality of the outcome and the surrealist's belief the outcome shows the common unconscious substratum among the creators.

[30] Cf. H. S. Davies, " Surrealism at This Time and Place," in H. Read, *Surrealism,* particularly pp. 138-148.

CHAPTER NINE

CODA

STARTING from realism it was possible to trace the various theories of art as mutations or denials of realist suppositions, and to see how certain crucial questions came into the aesthetics of painting which broadened and deepened that subject.

The ideas of realism were three: 1) beauty is a quality in objects, 2) the labor of the painter is exact copying of his model, 3) the work of art is an imitation of its model. As time progressed the first was discarded because it was seen to be in contradiction with the positivistic notion that metaphysics must be scrapped, and beauty was too loaded with the tradition of a metaphysical quality. It also lost out as denotative of aesthetic quality, for the tendency was more and more to locate aesthetic quality in the work of art as a character peculiar to it, something which the painter puts into his subject when he paints it which was not in the object. This latter notion arose when the painter saw that his labor was not merely copying, for in reproduction he did not always find so easily a beauty which made his work worthwhile. Hence, he was led to doubt the second idea of realism and to reëxamine the question of what artistry is. Here two paths were open to him. Either he could continue in the way set by realism, following the ideal of science but accepting more modern qualifications of scientific methodology and giving up the early positivistic notion of science as mere description. Or he could take an entirely new tack and claim that artistry is the rendition of his own sensibilities and feelings or of his private mental life. In either case he is brought to

doubt the third idea of realism. Here the crucial questions enter.

Those following the scientific ideal could ask: if painting is the rendering of what one perceives, what is the object as seen by the artist and is its nature affected by his perceptual activity? In brief the painter is faced with epistemological questions. And from this came a second question: how much does the artist's manner of rendering his model demand a reorganization of that model to comply with the form in which it is expressed? If the model is luminous surface, as for the impressionists or neo-impressionists, light is what he must record and on the canvas the model becomes a shimmer of divided strokes of pigment. Already we are started on the road to abstraction and the autonomy of art. In the theory of Cézanne the whole problem was how to render his sensations. In solving this the artist recognized that the painter's experiences in the natural world are distinctive and determined by his artistic activity, just as the scientist's are determined by his activity. Cubism distinguished a natural space and a pictorial space, the second governing the renditions of the artist.

Those turning away from the scientific ideal could ask: if the object seen is not the real model what is the subject of a painting? Or also, what does my painting tell me about the new subject I render? Renoir turned from the scientific ideal but never faced these questions. The symbolists made their subject the feelings of the artist and weakened the reference to the natural object. The surrealists reintroduced a traditional subject matter after the pure abstractionists had about gotten rid of it, but their subject matter was only a referent to an inner model. With these painters the problems were those of psychology.

The first group recognized the weakness of imitation

as a theory of art and sought to qualify it. The second group moved more wholeheartedly in the direction of expressionism.

Each aesthetic has a philosophical background that it reflects. When Courbet says beauty is in an object he is voicing the popularly accepted notion of the old realist theory in philosophy that qualities are inherent in objects. On the other hand, when he says it is the business of the artist to copy the object exactly he is reflecting the new positivistic point of view of his age that description is the sum of what we can understand about things. In impressionism's preoccupation with surface appearance one sees a definite turning away from any attempt to paint an essence or a typical example; the attitude of the painter has become completely non-metaphysical. The attempts of the neo-impressionists to lay down scientific schemes by which the painter may attain the harmony of formal elements are also perfect examples of positivistic explanation through description. Renoir, the symbolists, and the fauves find the artistic power in intuition, rebelling against any theories which reduce this faculty to intellect. This tendency among painters is a kind of Bergsonism. The distinction between the intellectual and the intuitive is fundamental to the philosophies of Bergson and Croce who both place the artistic on the intuitive side. The new positivism of Poincaré and the new rationalism of Meyerson find their counterpart in the theories of Cézanne and cubism. The knowing mind exerts its own influence in the process which begins in the artist's sensation of the natural world and terminates with his rendition of part of that world in a work of art. Cézanne's emphasis that the vision of the artist before nature is not the vision of the scientist or of the average man hints at a viewpoint that was later to come into great prominence in psychology and episte-

mology. Cubism, similar to new realism in philosophy and the new scientific thought, reduces the known object to a rationally conceived structure, the result of a mental construction. Finally, surrealism brings in the suppositions of Freudian psychology.

The problems of the painter are the problems of the philosopher, the enigmas of our knowledge of the external world.

BIBLIOGRAPHY

All titles mentioned in the text and works consulted are listed. The edition or translation given is the one used.

Alberti, Leon Battista. *Of Painting.* Translated into Italian by Cosimo Bartoli, now into English by James Leoni. London, 1726.

Apollinaire, Guillaume. *Les peintres cubistes.* Paris: Figuière, 1913.

Aragon, Louis. *La peinture au défi.* Paris: José Corti, 1930.

Aurier, Albert. " Le symbolisme en peinture." *Mercure de France.* II: 155-165. 1891.

Barnes, Albert C. and Violette de Mazia. *The Art of Cézanne.* New York: Harcourt, Brace, 1939.

Barr, A. H., Jr. *Cubism and Abstract Art.* New York: Museum of Modern Art, 1931.

———. *Fantastic Art, Dada, Surrealism.* New York: Museum of Modern Art, 1936.

———. *Henri Matisse Retrospective Exhibition.* New York: Museum of Modern Art, 1931.

Baudelaire, Charles. *Oeuvres complètes.* Vols. II and III. Paris: C. Levy, n. d.

———. *Variétés critiques.* Paris: Cres, 1924.

Benrubi, Isaac. *Contemporary Thought in France.* New York: Knopf, 1926.

———. *Les sources et les courants de la philosophie contemporaine en France.* Vol. I. Paris: Alcan, 1933.

Berenson, Bernard. *Florentine Painters of the Renaissance.* New York: Putnam's, 1901.

Bergson, Henri. *L'évolution créatrice.* Paris: Alcan, 1908.

———. *Introduction to Metaphysics.* New York: Putnam's, 1912.

Boas, George (ed.). *Courbet and the Naturalistic Movement.* Baltimore: The Johns Hopkins University, 1938.

———. *French Philosophies of the Romantic Period.* Baltimore: The Johns Hopkins University, 1925.

Bosanquet, Bernard. *History of Aesthetic.* London: Macmillan, 1892.

Bougot, Auguste. *Essai sur la critique d'art.* Paris: Hachette, 1877.

Bouvier, Émile. *La bataille réaliste.* Paris: Fontemoing, 1914.

Bréhier, Émile. *Histoire de la philosophie.* Vol. II, Parts 3 and 4. Paris: Alcan, 1932.

Breton, André (ed.). *Le surréalisme au service de la révolution.* May 15, 1933.

———. *Le surréalisme et la peinture.* Paris: Gallemard, 1928.

———. *Manifeste du surréalisme, poisson soluble.* Paris: Editions Kra, 1924.

———. *Position politique du surréalisme.* Paris: Éditions du Sagittaire, 1935.

———. *Second manifeste du surréalisme.* Paris: Éditions Kra, 1930.

———. " Surrealism: Yesterday, Today and Tomorrow." Translated by ?. *This Quarter.* V: 7-44. September, 1932.

———. *What is Surrealism?* Six essays translated by David Gascoyne (Criterion Miscellany no. 43). London: Faber & Faber, 1936.

Brett, George Sidney. *A History of Psychology.* Vol. III. New York: Allen & Unwin, 1921.

Bulletin of the Museum of Modern Art. IV. November-December, 1936.

Cassagne, Albert. *La théorie de l'art pour l'art en France.* Paris: Hachette, 1906.

Cennini, Cennino. *Le Livre de l'art.* Translated by Victor Mottez. Paris: J. Watelin, n. d.

Cézanne, Paul. *Correspondance.* Edited by John Rewald. Paris: Grasset, 1937.

Champfleury. *Le réalisme.* Paris: Michel Levy, 1857.

Cheney, Sheldon. *The Story of Modern Art.* New York: Viking, 1941.

Cherfils, M. *L'ésthetique positiviste.* Paris: A. Messien, 1909.

Cherniss, Ruth Meyer. *A Precursor of Nineteenth Century French Realism: Champfleury.* Abstract of thesis for Ph. D. Cornell, 1933.

Chevreul, Michel-Eugène. *De la loi du contraste simultane des couleurs.* Paris: Pitois-Levrault, 1839.

———. *Des couleurs et de leurs applications aux art industriels.* Paris: Bailliere, 1864.

Comte, Auguste. Cours de philosophie positive. Vol. V. Paris: Baillière, 1864.

Coquiot, Gustave. *Cubistes, futuristes, passéistes.* Paris: Ollendorff, 1923.

———. *Des peintres maudits.* Paris: Delpeuch, 1924.

———. *Les independents, 1884-1920.* Paris: Ollendorff, 1920.

Courbet, Gustave. "Manifestes de 1855 et de 1861." In Charles Leger. *Courbet.* Paris: Cres, 1929.

Cousturier, Lucie. *Seurat.* Paris: Cres, 1926.

Couture, Thomas. *Méthode et entretiens d'atelier.* Translated as *Conversations on Art Methods* by S. E. Stewart. New York: Putnam's, 1879.

Croce, Benedetto. *Aesthetic as a Science of Expression and General Linguistic.* Translated by Douglas Ainslie. London: Macmillan, 1909.

Dali, Salvador. *Conquest of the Irrational.* New York: J. Levy, 1935.

———. "The Object as Revealed in Surrealist Experiment." *This Quarter.* V: 197-207. September, 1932.

———. "The Stinking Ass." *This Quarter.* V: 49-54. September, 1932.

Dampier-Whetham, William Cecil. *History of Science.* Cambridge University, 1929.

David-Sauvageot, A. *Le réalisme et le naturalisme dans la litterature et dans l'art.* Paris: C. Levy, 1889.

Deffoux, Leon. *Le naturalisme: oeuvres représentatives.* Paris: Les Oeuvres Représentatives, 1909.

Degas, Hilaire, *Lettres.* Edited by Marcel Guerin. Paris: Grasset, 1931.

Delacroix, Eugène, Journal. 3 vols. Paris: Plot-Nourrit, 1926.

———. "Questions sur le beau." *Revue des Deux Mondes*, July 15, 1854.

Denis, Maurice. *De Gauguin et de Van Gogh au classicisme, théories: 1890-1900.* Paris: Watelin, 1913.

———. *Nouvelles théories.* Paris: Watelin, 1922.

Deschamps, Émile. *Préface des études françaises et étrangères.* 4ᵉ ed. Paris: Levasseur et Canel, 1829.

Dictionnaire abrégé du surréalisme. Paris: Galerie Beaux-Arts, 1938.

Ducasse, Curt J. *The Philosophy of Art.* New York: Dial Press, 1929.

Dumesnil, Réné. *Le réalisme.* Paris: Gigord, 1936.

Duret, Théodore. *Manet and the French Impressionists.* Translated by J. E. C. Flitch. Philadelphia: Lippincott, 1910.

Ernst, Max. "Inspiration to Order." *This Quarter.* V: 79-84. September, 1932.

Fénéon, Félix. *Les impressionistes en 1886.* Paris: Publications de La Vogue, 1886.

Ferran, André. *L'esthétique de Baudelaire.* Paris: Hachette, 1933.

Feidler, Konrad. *Schriften über Kunst.* 2 vols. Munich: Piper, 1913-1914.

Focillon, Henri. *La peinture aux XIXᵉ et XXᵉ siècles.* Paris: Libraire Renouard, 1928.

Fontaines, André. *Histoire de la peinture française.* Paris: Mercure de France, 1922.

Fouillée, Alfred. *Le mouvement positiviste.* Paris: Alcan, 1896.

Freud, Sigmund. *The Basic Writings of Sigmund Freud.* Edited and translated by A. A. Brill. New York: The Modern Library, 1938.

Fuller, B. A. G. *History of Philosophy.* New York: Holt, 1937.

Gascoyne, David. *A Short Survey of Surrealism.* London: Cobden Sanderson, 1935.

Gauguin, Paul. *Avant et après.* Paris: Cres, 1923.

———. *Diverses choses, 1896-1897.* MS of M. Daniel de Monfreid.

———. *Letters à Georges-Daniel de Monfried.* Paris: Cres, 1918.

———. *Noa-noa.* With Charles Morice. Paris: Cres, 1925.

———. *Racontars d'un rapin.* 1902.

Geoffroy, Gustave. *Claude Monet.* Paris: Cres, 1922.

Giedion, Sigfried. *Space, Time, and Architecture.* Cambridge: Harvard University, 1941.

Gilbert, Katharine and Helmut Kuhn. *A History of Aesthetics.* New York: Macmillan, 1939.

Gleizes, Albert and Jean Metzinger. *Du cubisme.* Paris: Figuière, 1912.

Goldwater, Robert J. *Primitivism in Modern Painting.* New York: Harper's, 1938.

Guérard, A. L. *French Civilization of the Nineteenth Century.* New York: Century, 1914.

Gunn, J. Alexander. *Modern French Philosophy.* London: T. Fisher Unwin, 1922.

Hendricks, Ives. *Facts and Theories of Psychoanalysis.* New York: Knopf, 1939.

Hammond, William A. *A Bibliography of Aesthetics and of the Philosophy of Art from 1900 to 1932.* New York: Longmans, Green, 1934.

Hevner, Kate. "Experimental Studies of the Affective Value of Colors and Lines." *Journal of Applied Psychology.* XIX: 385-398. August, 1935.

Hoffding, Harald. *A History of Philosophy.* Vol. II, translated by
B. E. Meyer. London: Macmillan, 1900.

Hogarth, William. *The Analysis of Beauty.* Pittsfield, Mass., 1909.

Hugnet, Georges. " L'esprit dada dans la peinture." Cahiers d'art
VII & IX. 1932 and 1934.

Huyghe, Réné. *Les contemporains.* Paris: Tisné, 1939.

Jenkins, Iredell. " Hippolyte Taine and the Background of Modern
Aesthetics." *Modern Schoolman.* XX.

Jung, C. G. Psychology of the Unconscious. Translated by Beatrice
Hinkle. New York: Dodd, Mead and Co., 1916.

Koffka, K. *Principles of Gestalt Psychology.* New York: Harcourt,
Brace, 1915.

König, Réné. *Die naturalistische ästhetik in Frankreich und und ihre
Auflösung.* Borna-Leipzig: R. Noske, 1931.

Larroumet, Gustave. " L'art réaliste et la critique." *Revue des Deux
Mondes.* December 15, 1892 and March 1, 1893.

Laver, James. *French Painting in the Nineteenth Century.* London:
Botsford, 1937.

Lecomte, Georges. *Camille Pissarro.* Paris: Bernheim-Jeune, 1922.

Léger, Charles. *Courbet.* Paris: Cres, 1929.

————. *Courbet selon les caricatures et les images.* Paris: Rosenberg,
1920.

Lemaître, Georges. *Cubism and Surrealism in French Literature.*
Cambridge: Harvard University, 1941.

Lenoir, P. *Histoire du réalisme.* Paris: Quantin, 1889.

Leonardo da Vinci. *Literary Work.* 2 vols. Compiled and edited by
J. P. Richter and I. A. Richter. London: Oxford, 1939.

Levy, Julien. *Surrealism.* New York: Black Sun, 1936.

Lévy-Bruhl, Lucien. *History of Modern Philosophy in France.* Trans-
lated by G. Coblence. Chicago: Open Court, 1899.

————. *The Philosophy of Auguste Comte.* Translated by Kathleen
de Beaumont-Klein. London: Sonnenschein, 1903.

Lipps, Theodor. *Zur Einfühlung.* Leipzig: Engelmann, 1913.

Listowel, The Earl of. *A Critical History of Modern Aesthetics.*
London: Allen & Unwin, 1933.

Marriott, Charles. *A Key to Modern Painting.* London: Blackie,
1938.

Martineau, Harriett. *Comte's Positive Philosophy.* Vol. III. Lon-
don: G. Bell & Sons, 1896.

Martino, Pierre. *Parnasse et symbolisme.* Paris: Colin, 1935.

Matisse, Henri. " Notes d'un Peintre." *Grande Revue.* December 25, 1908.

———. Interview to Guillaume Appollinaire. *La Phalange.* December 15, 1907.

———. Interview to E. Teriade. *L'intransigeant.* January, 1929.

Mead, George. *Movements of Thought in the Nineteenth Century.* Chicago: University of Chicago, 1936.

Merz, John T. *History of European Thought in the Nineteenth Century.* 4 vols. Edinburgh and London: W. Blackwood & Sons, 1903-04.

Meyerson, Émile. *Identité et réalité.* Paris: Alcan, 1912.

Michel, André. Histoire d'art. Vol. VIII, part 2. Paris: A. Colin, 1926.

Mondrian, Piet. *Néo-plasticisme.* Paris: Effort Moderne, 1920.

Moreau-Nélaton, Étienne. *Manet raconté par lui-même.* 2 vols. Paris: Laurens, 1926.

Morice, Charles. *Paul Gauguin.* Paris: Floury, 1920.

Mustoxidi, T. M. *Historie de l'esthétique française 1700-1900.* Paris: Champion, 1920.

Needham, H. A. *Le développement de l'esthétique sociologique.* Paris: Champion, 1925.

Ozenfant, Amádée, and Charles-Edouard Jeanneret. *Après le cubisme.* Paris: Éditions des Commentaires, 1918.

Ozenfant, Amádée, and Charles-Edouard Jeanneret. *La peinture moderne.* Paris: Povolsky, c. 1920.

Pach, Walter. " Pierre-August Renoir." *Scribner's Magazine.* May, 1912.

Peirce, Charles Sanders. *Collected Papers*, Vol. II. Cambridge: Harvard University, 1932.

Plato. *Dialogues.* Translated by B. Jowett. Oxford University, 1892.

Poincaré, Henri. *Science and Hypothesis.* Translated by George Bruce. New York: Science Press, 1905.

Praz, Mario. *The Romantic Agony.* Translated by Davidson Angus. Oxford University, 1933.

Prinzhorn, Hans. *Bilderei der Geisteskranken.* Berlin: J. Springer, 1923.

Proudhon, P. J. *Du principe de l'art.* Paris: Garnier Frères, 1865.

Quintanilla, Luis. *Bergsonisme et politique.* Ph. D. thesis. The Johns Hopkins University, 1938.

Rader, Melvin. *A Modern Book of Aesthetics.* New York: Holt, 1933.

Raphael, Max. *Proudhon, Marx, Picasso.* Paris: Éditions Excelsior, 1933.

Raymond, Marcel. *De Baudelaire au Surréalisme.* Paris: Correa, 1933.

Raynal, Maurice. *Modern French Painters.* New York: Brentano, 1928.

Read, Herbert (ed.). *Surrealism.* New York: Harcourt, Brace, 1937.

Redon, Odilon. *Memoires à soi-même.* Paris: Floury, 1922.

Reid, Louis A. *A Study in Aesthetics.* London: Allen & Unwin, 1931.

Renoir, Auguste. " La Société des Irregularistes." In Venturi, *Les Archives de l'impressionnisme.* Paris: Durand-Ruel, 1939.

———. Lettre à Henry Mottez. In Cennini, *Livre de l'art.*

Rewald, John. *Gauguin.* Paris: Hyperion, 1938.

———. *Seurat.* New York: Wittenborn, 1943.

———. *The History of Impressionism.* New York: Simon & Schuster, 1946.

Rey, Robert. *La renaissance du sentiment classique.* Paris: Beaux Arts, 1921.

Reynolds, Joshua. *Discourses on Art.* London: J. Carpenter, 1842.

Rhodes, Solomon. *The Cult of Beauty in Charles Baudelaire.* 2 vols. New York: Columbia University, 1929.

Ribot, Théodule. *Essai sur l'imagination créatrice.* Paris: Alcan, 1921.

Rich, Daniel C. *Seurat and the Evolution of " La Grande Jatte."* Chicago: University of Chicago, 1935.

Rood, Ogden Nicholas. *Modern Chromatics with Applications to Art and Industry.* New York: Appleton, 1879.

Rosenthal, Leon. *Du romantisme au réalisme.* Paris: Laurens, 1914.

Rothschild, E. F. *Meaning of Unintelligibility in Modern Art.* Chicago: University of Chicago, 1934.

Rotonchamp, Jean de. *Paul Gauguin 1848-1903.* Paris: Cres, 1925.

Russell, Bertrand. *Our Knowledge of the External World.* London: Open Court, 1914.

Salon de 1863. Paris: Morgues, 1863.

Santayana, George. *The Sense of Beauty.* New York: Scribners, 1896.

Schinz, Albert. " Dada, poignée de documents." *Smith College Studies in Modern Languages.* October, 1923.

Serouya, Henri. *Initiation à la peinture d'aujourd'hui.* Paris: Renaissance du livre, n. d.

Signac, Paul, *D'Eugène Delacroix au néo-impressionnisme.* 3e ed. Paris: Floury, 1921.

———. " Le néo-impressionnisme: documents." *Gazette des Beaux Arts.* Per. 6, XI: 49-59. January, 1934.

Silvestre, Théophile. *Artistes français.* 2 vols. Paris: Cres, 1926.

Stein, Leo. *The A-B-C of Aesthetics.* New York: Boni & Liveright, 1927.

Sweeney, James J. *Plastic Redirections in the Twentieth Century.* Chicago. University of Chicago, 1934.

Taine, Hippolyte. *Philosophy of Art.* Translated by John Durand. New York: Holt, 1875.

Topass, Jan. *La pensée en revolte.* Brussels: Henriquez, 1935.

Tzara, Tristan. *Sept. manifestes dada.* Paris: Budry, 1921.

Urban, Wilber. *Language and Reality.* London: Allen & Unwin, 1939.

Van Gogh, Vincent. *Letters to His Brother.* 3 vols. London: Constable, 1927-1929.

———. *Letters to Émile Bernard.* Translated by Douglas Lord. London: Cressit, 1938.

Venturi, Lionello. *Cézanne.* 2 vols. Paris: Rosenberg, 1936.

———. *History of Art Criticism.* Translated by Charles Marriott. New York: Dutton, 1936.

———. *Les archives de l'impressionnisme.* 2 vols. Paris: Durand-Ruel, 1939.

Véron, Eugène. *L'esthétique.* Paris: C. Reinwald, 1878.

Vischer, Robert. *Aesthetik.* 6 vols. Munich: Meyer & Jens, 1922-1923.

Vlaminck, Maurice de. *Polement.* Paris: Stock, 1931.

Vollard, Ambrose. *Renoir, an Intimate Record.* Translated by Randolph T. Weaver. New York: Knopf, 1925.

Whistler, James M. *The Gentle Art of Making Enemies.* New York: Putnam's, n. d.

Wilenski, Reginald. *French Painting.* Boston: Hale, Cushman & Flint, 1931.

———. *Modern French Painters.* New York: Reynald and Hitchcock, 1940.

———. *The Modern Movement in Art.* London: Faber and Guyer, 1928.

Windelband, Wilhelm. *History of Philosophy.* Translated by James Tufts. New York: Macmillan, 1901.

Zimmermann, Robert. *Aesthetik.* Vienna: Braumüller, 1858-1865.

Zola, Émile. *Mes haines.* In *Oeuvres complètes.* Vol. XL. Paris: Bernouard, 1927-1929.

INDEX